MISSION:IMPOSSIBLE ™

GHOST PROTOCOL ™

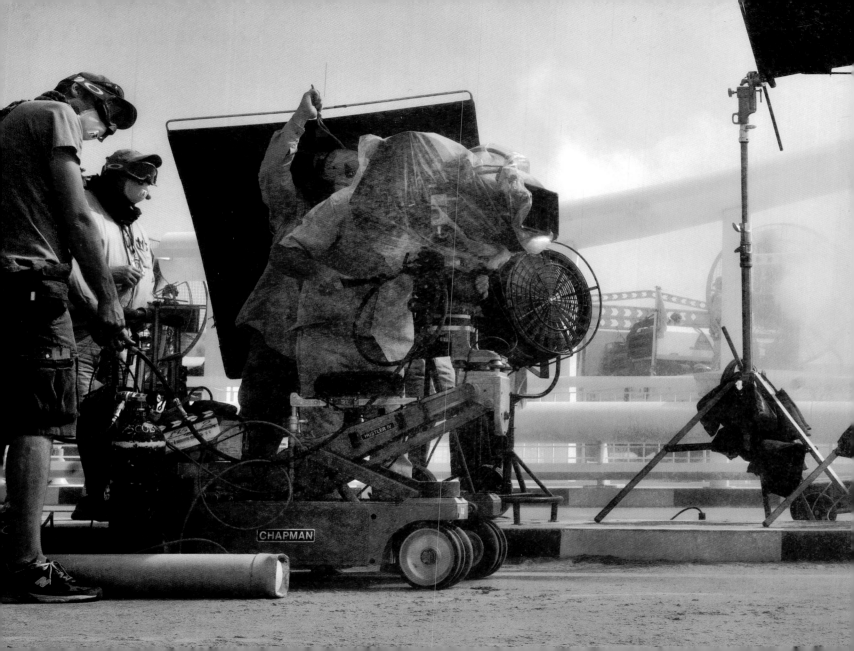

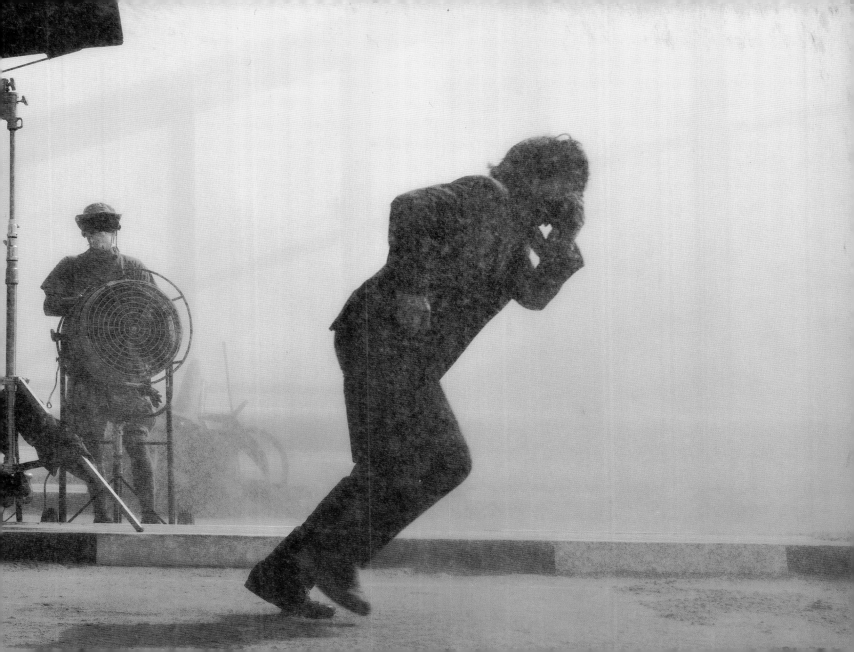

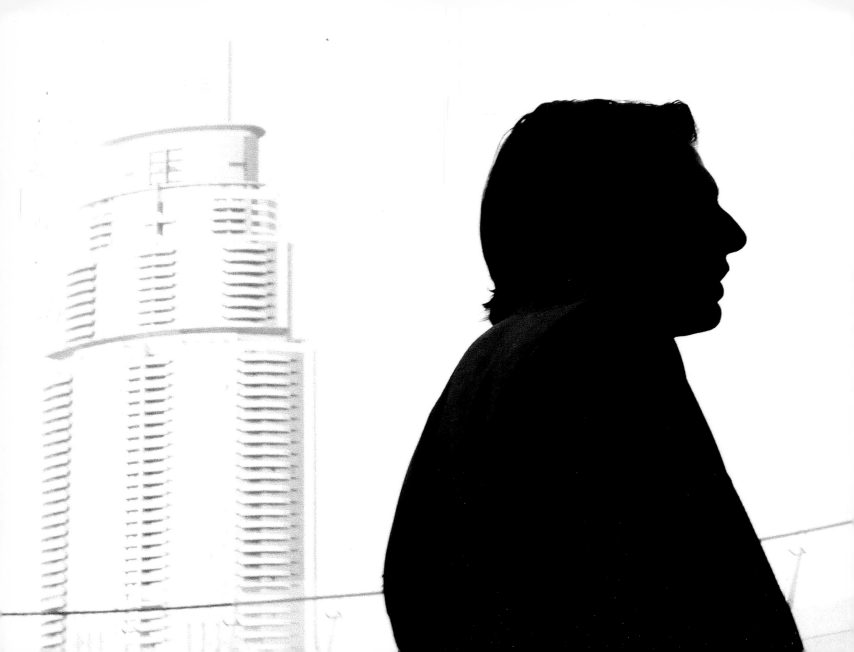

MISSION:IMPOSSIBLE
GHOST PROTOCOL
SHOOTING DIARY
BY DAVID JAMES

FOREWORD BY **TOM CRUISE**

INSIGHT EDITIONS

San Rafael, California

I N S I G H T **E D I T I O N S**

PO Box 3088, San Rafael, CA 94912
www.insighteditions.com

Design by Dagmar Trojanek

Library of Congress Cataloging-in-Publication Data available.

ISBN: 978-1-60887-098-1

ROOTS of PEACE REPLANTED PAPER

Insight Editions, in association with Roots of Peace, will plant
two trees for each tree used in the manufacturing of this book.
Roots of Peace is an internationally renowned humanitarian
organization dedicated to eradicating land mines worldwide
and converting war-torn lands into productive farms and
wildlife habitats. Together, we will plant two million fruit and
nut trees in Afghanistan and provide farmers there with the
skills and support necessary for sustainable land use.

Manufactured in China by Insight Editions

10 9 8 7 6 5 4 3 2 1

PAGES 2–3 Tom Cruise braves a special effects sandstorm
on the Meydan Racecourse in Dubai.

PAGES 4–5 Tom at the base of Dubai's Burj Khalifa, the tallest
building in the world.

THESE PAGES Ethan (Tom Cruise) helps Brandt (Jeremy Renner)
escape while under fire and underwater.

PAGES 8–9 Director Brad Bird shows Tom where he needs to
place his hand for an insert shot that will be part of the scene
where Ethan climbs the Burj Khalifa.

PAGES 10–11 Tom is about to launch out of the 164th floor
of the Burj Khalifa.

PAGES 12–13 A tense moment between Ethan and Brandt
in the Dubai safe house.

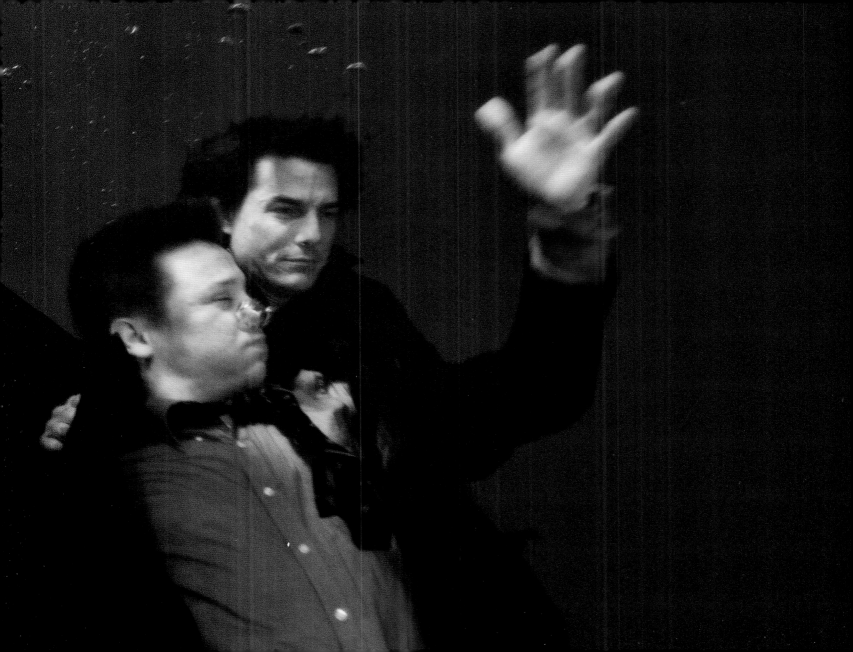

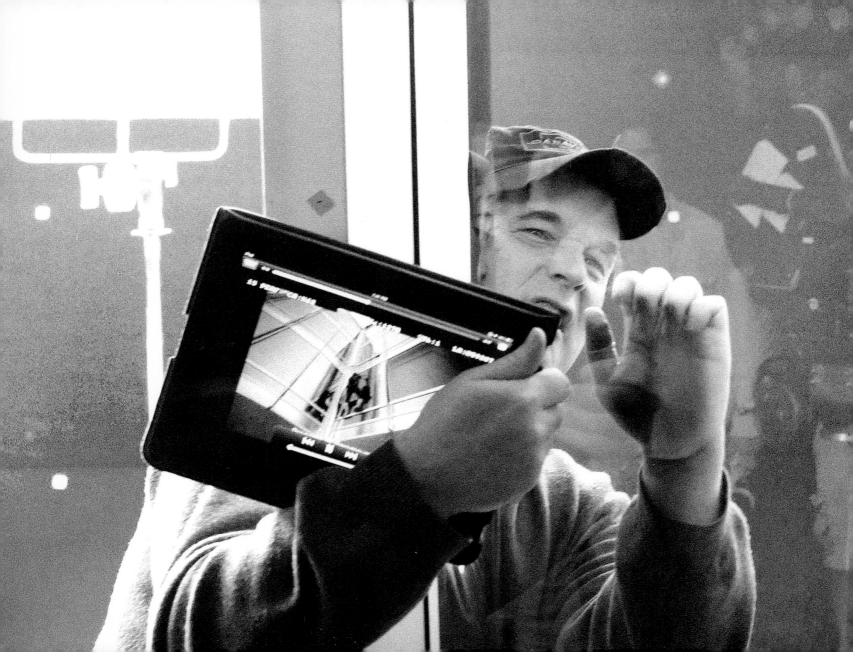

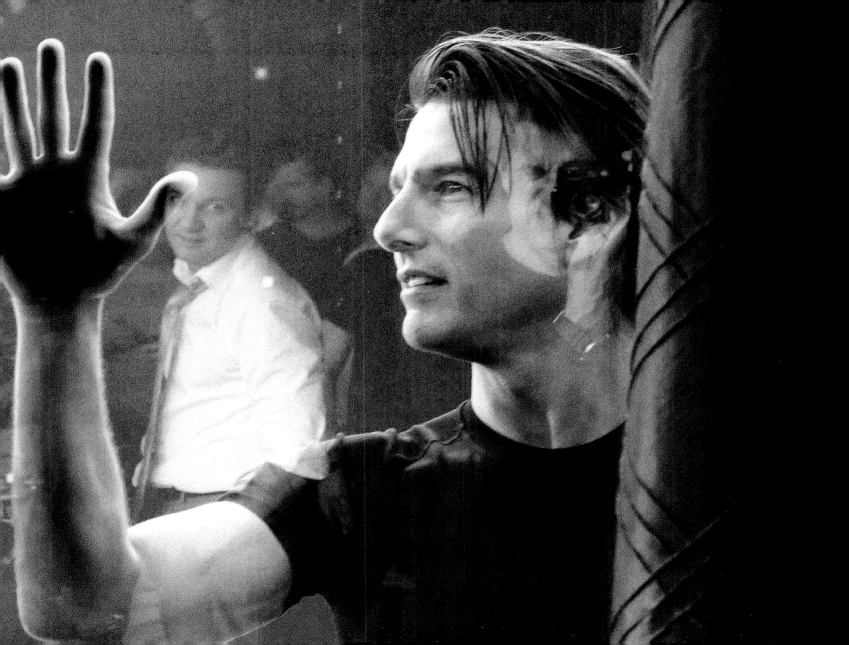

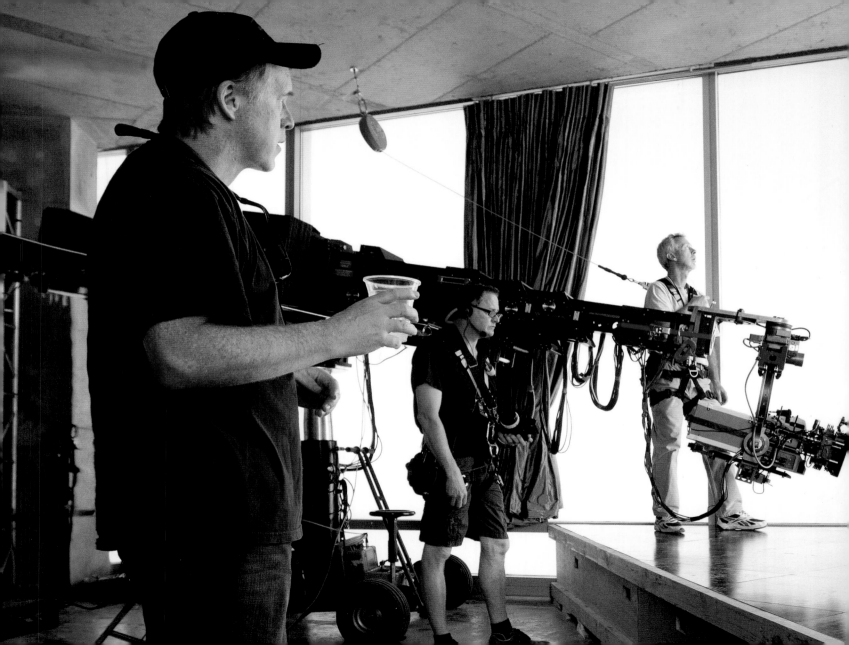

CONTENTS

22 **LOS ANGELES**
SEP 02 – 22 · 2010

32 **PRAGUE**
SEP 23 – OCT 22 · 2010

76 **DUBAI**
OCT 29 – NOV 20 · 2010

15 **FOREWORD**
TOM CRUISE

17 **INTRODUCTION**
DAVID JAMES

122 **VANCOUVER**
DEC 08 · 2010 – MAR 17 · 2011

208 **ABOUT THE PHOTOGRAPHER**

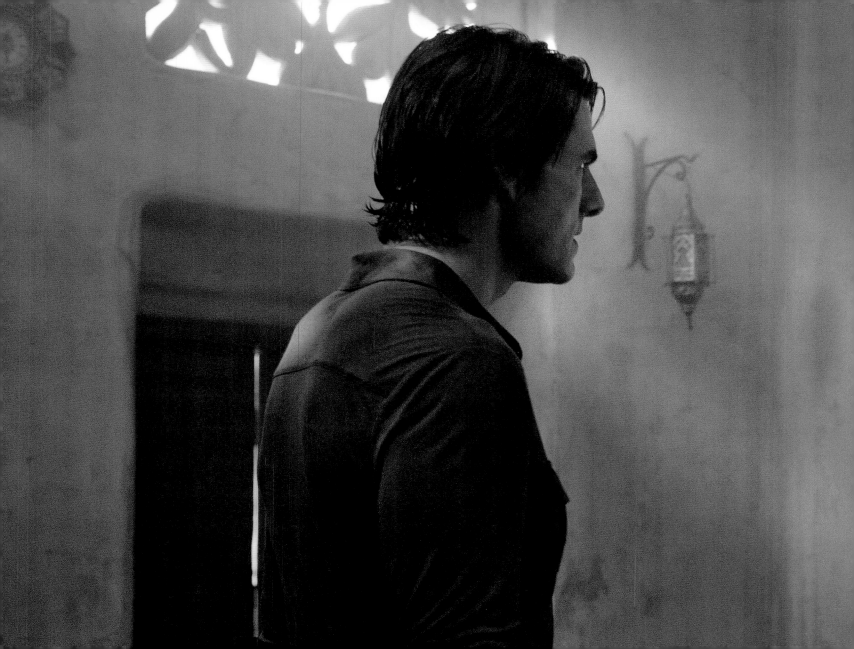

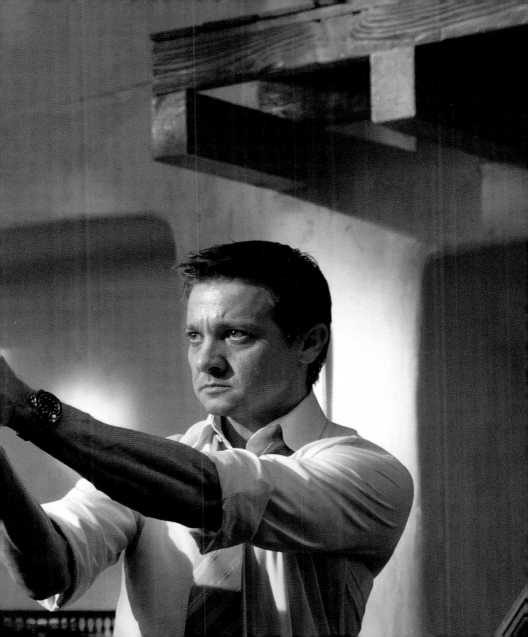

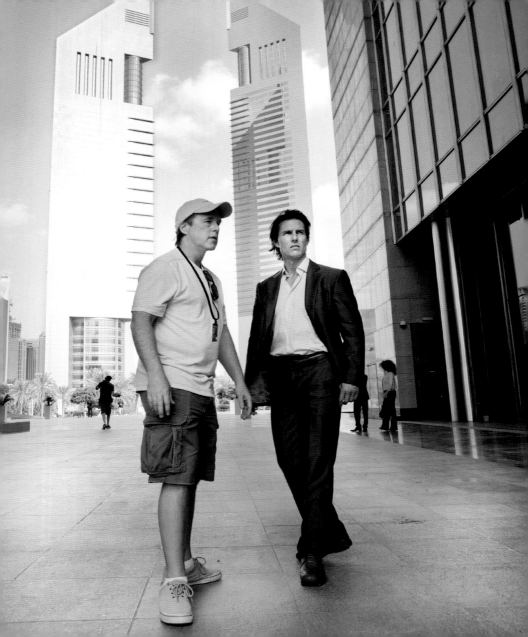

FOREWORD TOM CRUISE

I GREW UP WATCHING *MISSION: IMPOSSIBLE* AS A KID. ■ EACH WEEK MY FAMILY AND I WOULD GATHER IN FRONT OF OUR TV AND FOR ONE INCREDIBLE HOUR, WE WERE ALL TRANSPORTED TO AN AMAZING WORLD OF GADGETRY, INTRIGUE, AND SUSPENSE. IT WAS PURE ENTERTAINMENT!

I am privileged to be able to enjoy the hell out of making and producing movies. And it was due to my affinity for *Mission: Impossible* that I approached Paramount with the idea of producing and starring in a film based on the series. ■ Now, fifteen years later, embarking on my fourth *Mission*, I asked David James, with whom I have worked on six other films, to join our IMF team as the stills photographer. We share the same excitement about cinema, and, frankly, he's the best there is. I knew he would be up to the challenges this adventure had in store, and this book is a wonderful tribute to his stunning photography and Brad Bird's incredible storytelling ability. ■ David's role on a film set is an important but often unheralded element of the filmmaking process. His daunting task is to take a medium that is built around moving images and sound and capture the film's story, character, and scope through still photographs. More often than not this photography will be the first impression the audience has of a film before its release, through use in promotional materials all over the world. To capture the images, David often finds himself in unique situations, and on a *Mission: Impossible* movie, the hours are long and the conditions are rough-and-tumble and can, at times, be dangerous . . . especially when he's keeping up with Ethan Hunt and the *MI* team. ■ David has honed his artistic skills expertly during an amazing career that has spanned more than four decades and over 80 films. I have tremendous respect for his talent. ■ I hope you enjoy David's visual history of *Mission: Impossible – Ghost Protocol*, as lived by a dedicated and hardworking cast and crew, helmed by our extraordinary director, Brad Bird.

OPPOSITE Brad Bird and Tom Cruise discuss a scene in the center of Dubai.

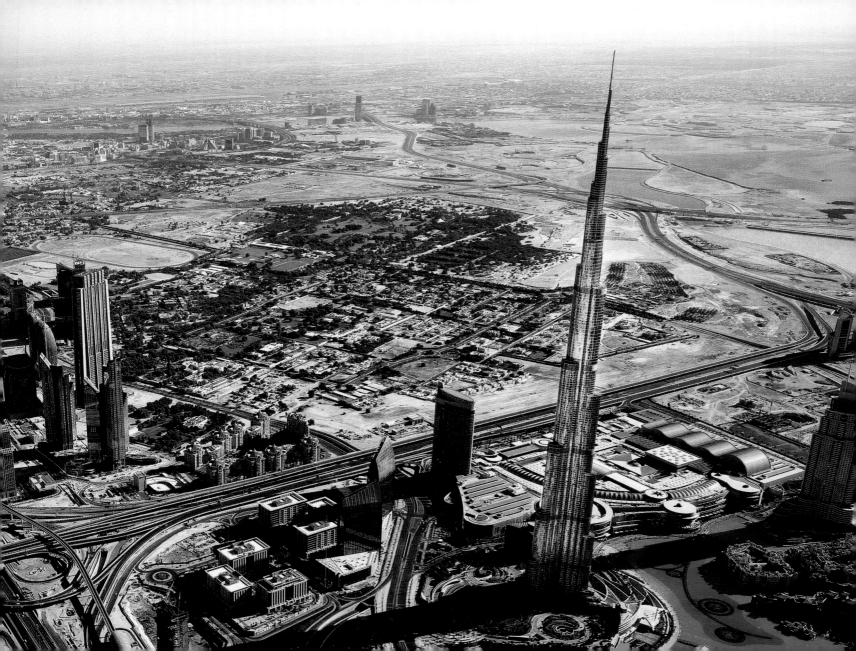

INTRODUCTION

I WAS ON A PERFECT WHITE-SAND BEACH IN JAMAICA. AFTER A COUPLE OF WEEKS THERE SHOOTING WITH TOM CRUISE AND A BIKINI-CLAD CAMERON DIAZ (TOUGH JOB, I KNOW, BUT SOMEONE HAS TO DO IT), IT WAS THE END OF OUR FINAL DAY. I WAS WALKING OFF THE BEACH SET WITH TOM. HE TURNED TO ME AND SAID, "YOUR NEXT MISSION, SHOULD YOU CHOOSE TO ACCEPT IT, IS TO SHOOT WITH ME ON THE NEXT *MISSION: IMPOSSIBLE* MOVIE."

OK, what he really said was, "I would love it if you would do the next *Mission* movie with me." I had done a special shoot on *Mission: Impossible III* in Shanghai for a week and loved working with the team. Naturally, I jumped at the offer to join up for the fourth film in the series. *Mission* movies are known for their action and travel, and *Mission: Impossible – Ghost Protocol* had its own particular exotic itinerary, with location shoots planned in Prague, Dubai, and Vancouver. I had only one special request: that we organize a special shoot that would be a one-off, which would produce an iconic image of Tom. ■ Rehearsals started in August 2010 on Stage 18 at Paramount Studios in Hollywood. A sixty-foot-high glass wall had been built for Tom to work out how his character Ethan Hunt would scale the half-mile-high Burj Khalifa in Dubai, which was an incredible stunt called for in the script. The bar was set from the start: This was going to be challenging. ■ The first leg of our journey and the start of shooting took us to the historic and beautiful city of Prague. I had shot in Prague only once before, when working on *Yentl* with Barbra Streisand in 1982. Back then, the city was under Communist control. The Prague of 2010 was completely different. It was bustling with life and, I have to say, is home to many great restaurants. The city is a photographer's paradise, and I never went out without a camera. ■ We stayed in Prague for just over a month,

OPPOSITE The Burj Khalifa dominates the Dubai skyline. Tom Cruise is the dot on the top of the building.

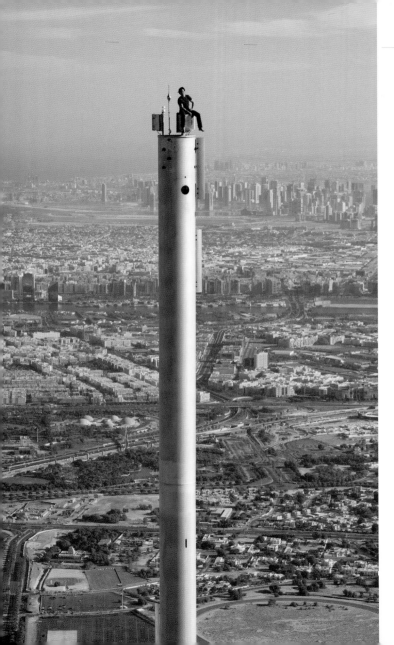

shooting the needed scenes and getting up to speed with one another's ways of working. It is always interesting to observe a company swing into a working pattern. Watching our director Brad Bird find his feet on his first live-action movie was amazing. From the outside looking in, you would have thought he had done numerous live-action films. He was completely comfortable and took charge from the very start. ■ After five weeks, we moved to Dubai, away from the cold and rain of Eastern Europe in the fall to the bright desert of the Middle East. Here I have to thank my wife, Dian, who had thought ahead and carefully packed clothes for the three different climates we'd encounter on this shoot. I would have been totally unprepared without her. ■ Unlike Prague, I had never been to Dubai, which has always fascinated me. It is the opposite of Prague in many ways—an extremely modern metropolis that has expanded exponentially over the past fifty years. The first morning in Dubai, I went to my hotel window and looked up, up, and up. Towering above was the Burj Khalifa, the tallest building in the world at a half a mile high (its exact height is 2,716.5 feet). I thought: Wouldn't it be great if I could get a picture of Tom sitting right up there on the top? I believe Tom may have looked out his window and had the same thought. ■ After many talks and meetings with locations people and producers

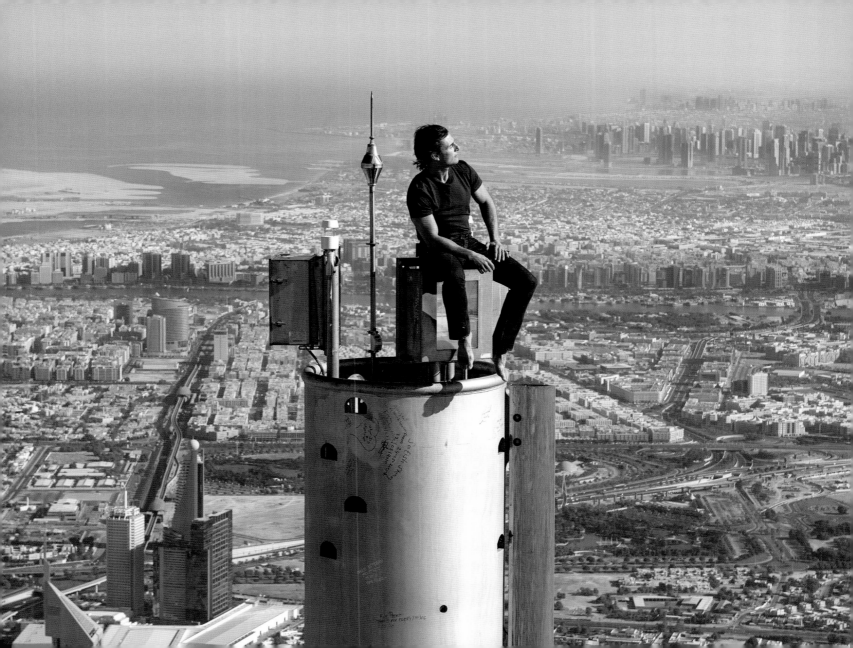

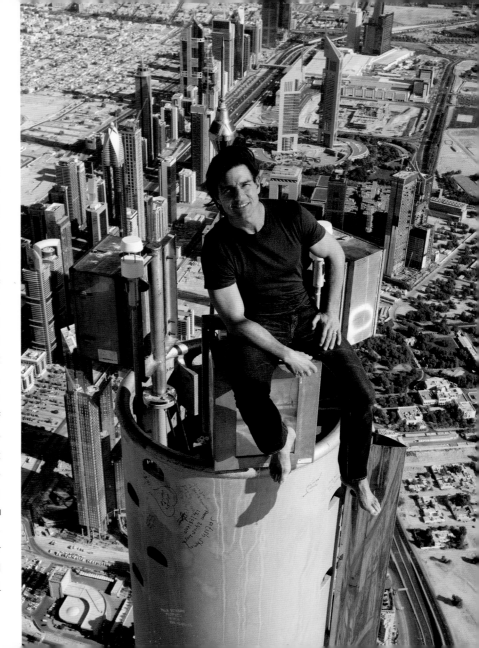

seeking permissions, I made three trips in a helicopter to plan the shoot. During one of them, we put a stunt double up there to see how close I could get without blowing him off the top with the prop wash. ■ During my scouts, I determined that the morning was the best time of day to photograph, before the haze and dust of the day begins to accumulate at around 10:30 A.M. So at 9:00 A.M. on the day of the shoot, I went to the airport and began to rig the helicopter. There was no need for a cappuccino that morning; the adrenaline had started kicking in days before. ■ Tom had left his hotel earlier that morning and arrived at the Burj at 6:30 A.M. After completing a one-and-a-half-hour warm-up, he ascended in several elevators to floor number 250. From there, he climbed to the top of the building via a series of rungs that run vertically inside the gray tube on top of the Burj. Stunt coordinator Gregg Smrz and climbing specialist David Schultz accompanied him. The climb took about one hour and forty-five minutes. There was no air-conditioning inside the tube, and it gets hot very quickly in Dubai. ■ Meanwhile, Marc Wolff (probably the best camera helicopter pilot on the planet) and I checked over the helicopter at the airport. I had a Red digital camera rig mounted so I could shoot some moving stills of the shoot. We got the call

from an assistant director that Tom was at the top and lifted off. Fifteen minutes later, we were flying around the tower to the surprise of everyone. We were too early: Tom still had to be secured to the tower with a safety line. Marc and I landed in a parking lot and waited. Unfortunately, we couldn't shut the helicopter down and had to burn precious fuel while we took a coffee break. ■ At last the call came and off we went again, climbing to an altitude of 2,800 feet. I had radio communication with Tom through Marc and Gregg, who passed on my directions. We did several passes, some coming really close to Tom and then pulling away to reveal the background. And what a backdrop—it seemed the whole world was behind and below him! The thinking with these shots was that I would start close with the Red camera, establish a good frame, then pull back to show the surroundings, and then reverse the shot. The idea with this sequence is that you start with a long wide shot and end up with a nicely framed close-up. With the wind and air currents we had to fight when shooting from a helicopter at that elevation, it was hard to do it the other way. There were times that we got so close, I felt like I could have reached out to shake Tom's hand. ■ After a few passes, the shot was in the bag, turning out just like I had envisioned it: the top movie star in the world sitting barefoot and smiling on the top of the tallest building in the world. I could have carried on for a lot longer, but the fuel light started flashing red. And Tom still had to climb down and make it to the set that afternoon. ■ While Tom descended, Marc and I returned to the airport and made our way to the set and met up with him. The three of us buzzed with adrenaline all day. My first words to Tom were, "What's next?" ■ "We'll find something," he said.

SEP 02 - 22 2010

LOS ANGELES

SEP 02 · 10 12:40:53

Stage 18, Paramount Studios, Los Angeles. Watching an actor's mental wheels turn is always a fascinating thing. Here, Tom Cruise had been watching the *Mission: Impossible – Ghost Protocol* stunt team work out how his character, Ethan Hunt, would climb the glass wall exterior of the Burj Khalifa, the tallest building in the world, located in Dubai, using a specially designed pair of gloves. He watched patiently for a while and then stepped in to show them exactly how it should be accomplished.

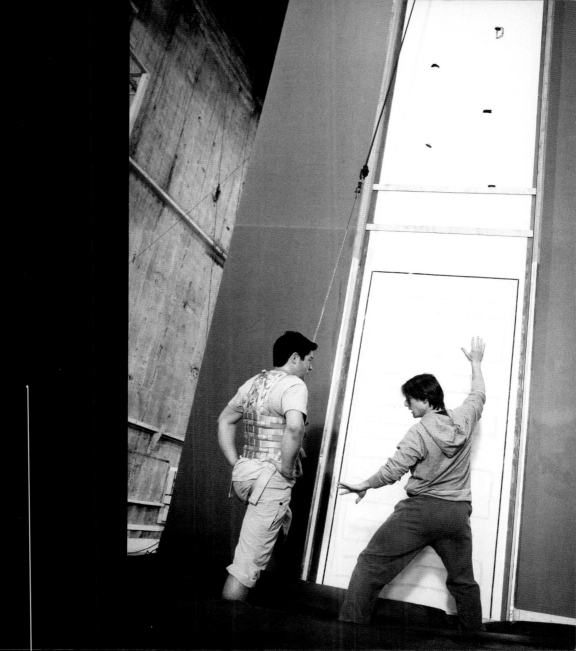

▪ SEP 09 10 ⌈ 15:03:12 ⌉

Tom gets harnessed up for a climb on the practice wall. He did this routine many times to prepare for the actual scenes. The practice wall was sixty feet high, while the actual location in Dubai, which we would visit later, is a half a mile high. At this point in the filming, I was already trying to work out how I would get those shots on the Burj Khalifa.

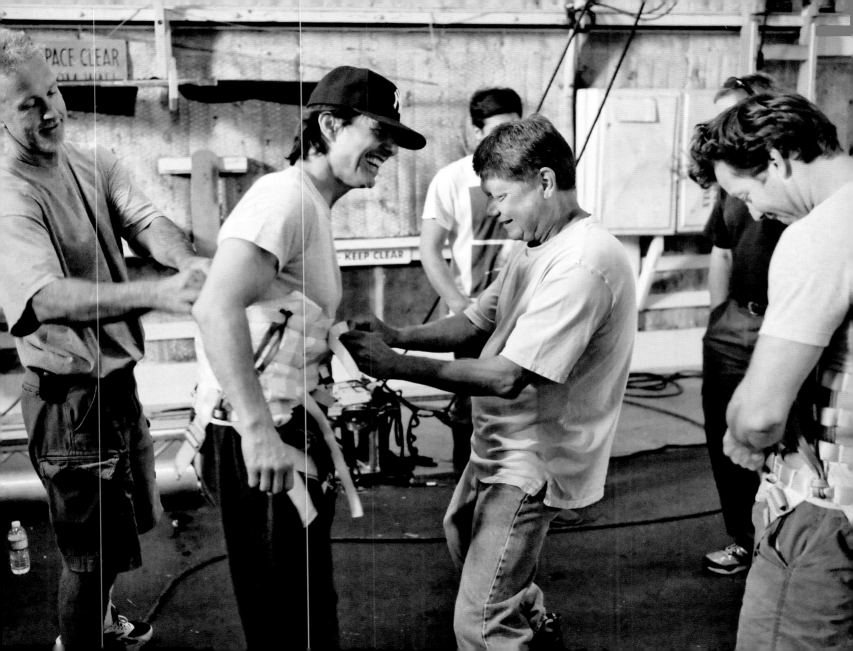

SEP 09 · 10 [16:07:51]

Tom takes his first climb on the stage wall. He's already cracked it, right down to how the glove has to smack against the glass to get adhesion.

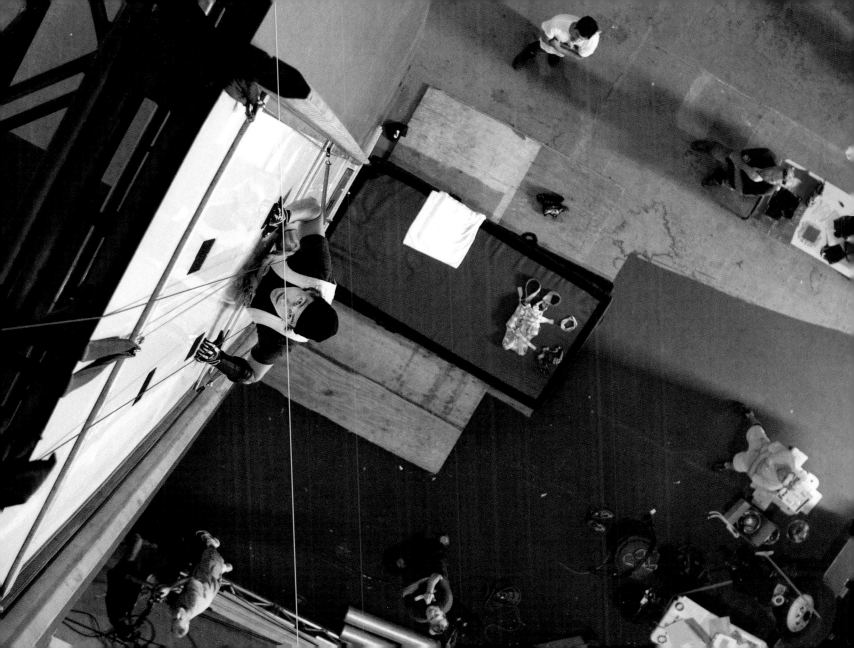

SEP 22 ˙10 06:58:15

A day of firsts: Director Brad Bird is relaxed on the first day of tests. It's not just the first day of filming *Mission: Impossible – Ghost Protocol*. It's also Brad's first day of shooting live action since his background is in animation. Even so, there's no sign of nerves. He's completely relaxed and enjoying himself.

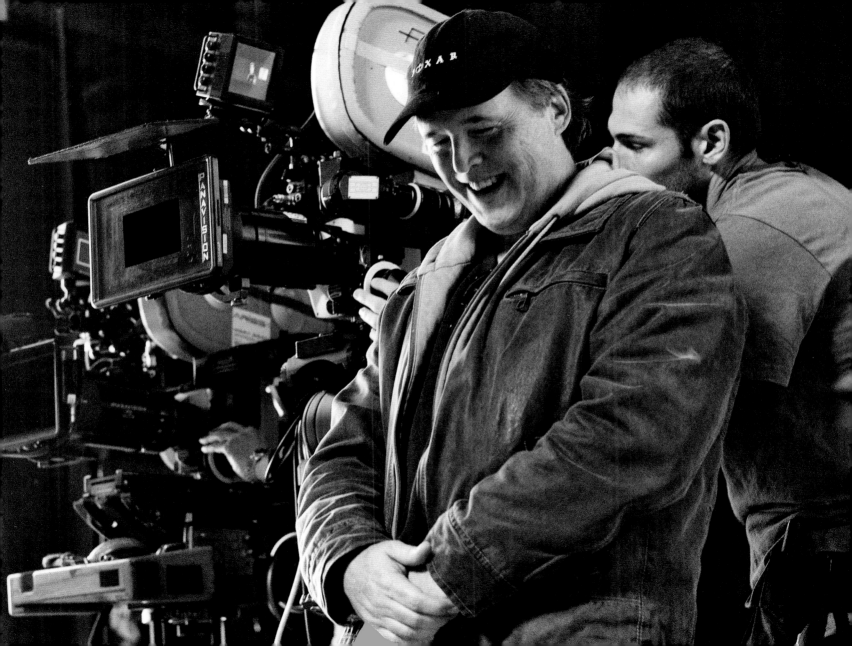

SEP 23 – OCT 22 2010

PRAGUE

SEP 23 10 [09:05:13]

A costume test on actress Paula Patton, who plays Jane Carter, a new member of the Impossible Mission Force (IMF) team. The red balloon and camera are key props for her scene in Red Square, Moscow. But that scene will be shot way down the line, partly in Dubai and partly in Vancouver.

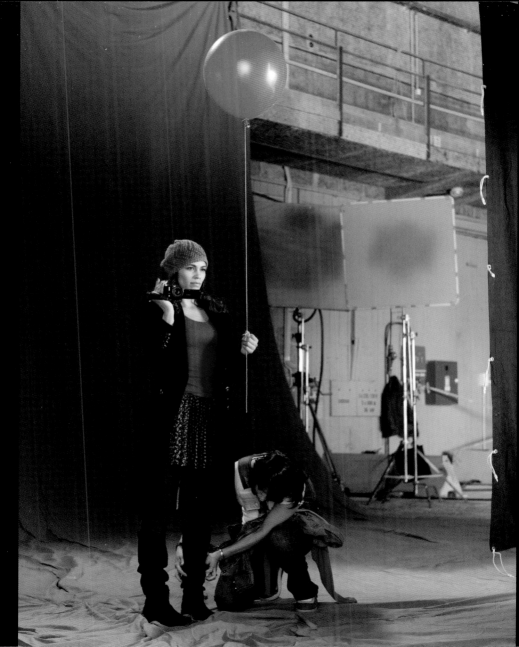

SEP 23 ' 10 [10:03:50]

Director of photography Robert Elswit lines up the camera to roll on the first tests. It's also an important day for him, as he gets to look at costume colors and assess different camera angles for each of the actors.

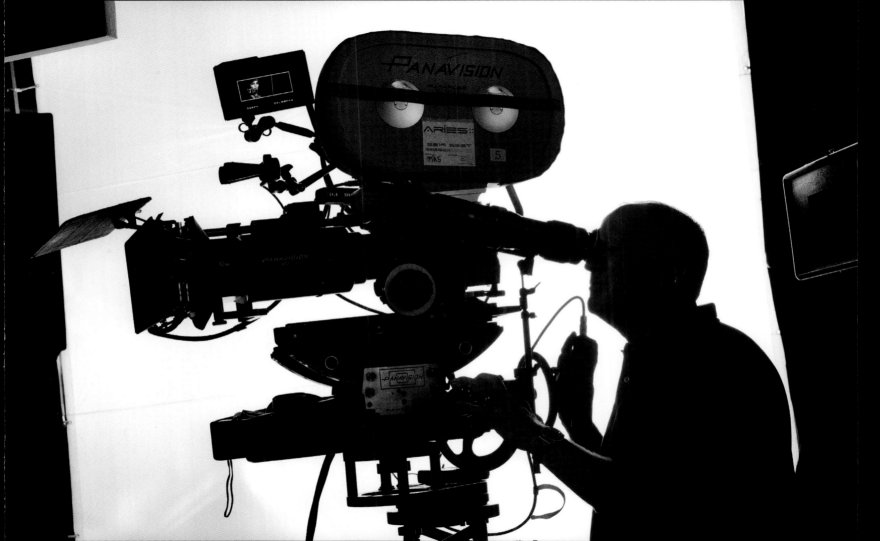

SEP 29 10 [10:50:30]

The mission: Ethan has to get into the senate building in the Kremlin, lift some important files, and get out without being detected. How do you prepare for such an operation? Simple: Open your bag of tricks, dress up as a Russian general, change your face a little, and there you are. Then you can just walk past any guard, through the main gate, and off you go.

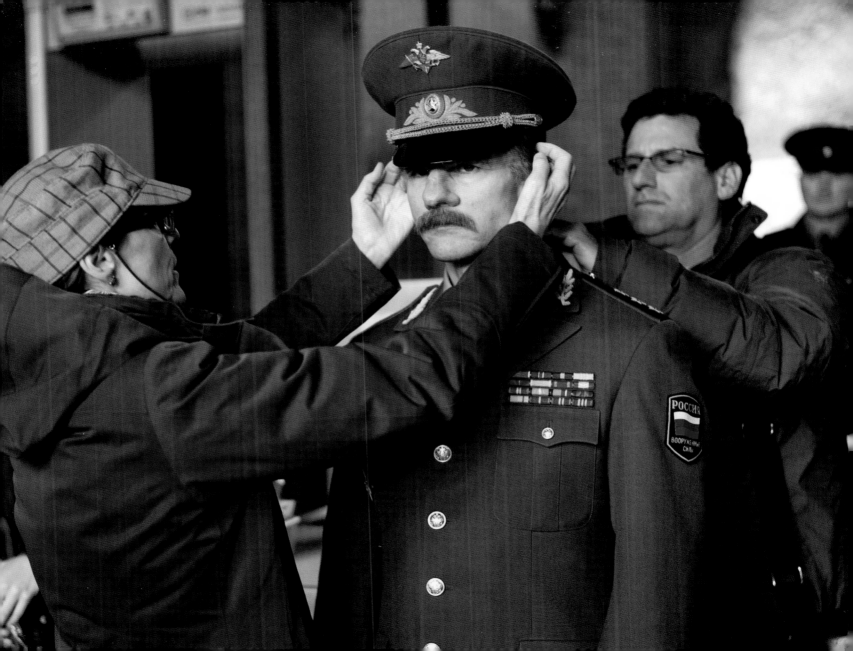

SEP 29 ' 10 [17:05:02]

First-day lineup. The set is the exterior of the Kremlin, which is actually outside one of the oldest forts in Prague, Vyšehrad castle. Brad and Tom walk through and block out the scene where Ethan discards the Russian general disguise. Vyšehrad castle was built in tenth century and was for a time the royal seat of Prague. Many locals believe the castle is built on the location of the initial settlement that would later become the city.

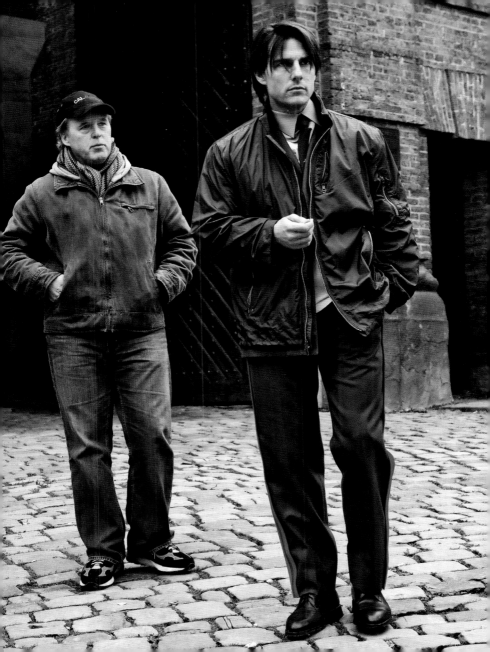

SEP 30 · 10 [22:15:09]

A Russian prison? No, this is a decommissioned Czech Communist prison about an hour outside of Prague that the *Mission* production team turned into a present-day Russian institution.

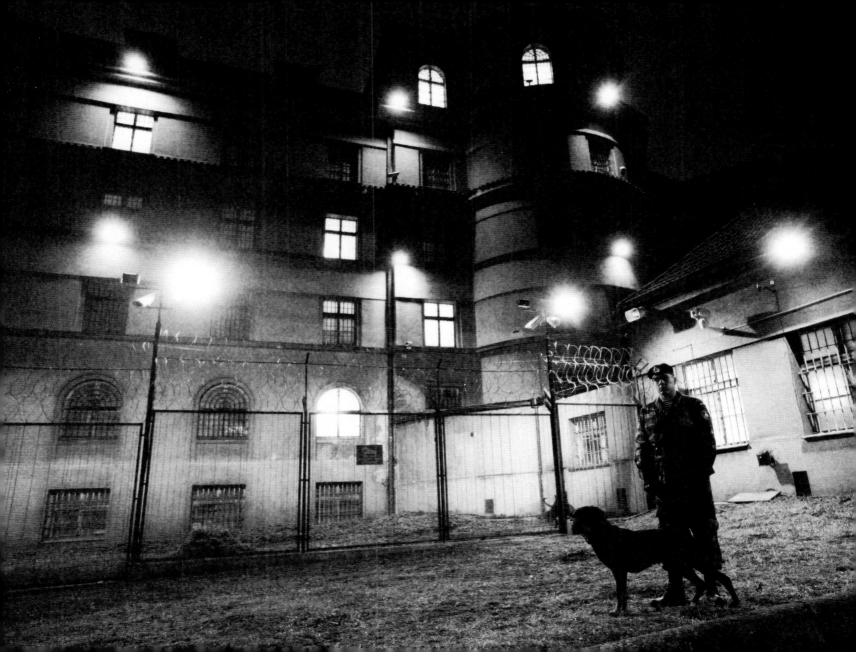

OCT 01 ' 10 [08:48:15]

Ethan and Benji hear a voice over the intercom say "stand by to detonate," but it's not one of their team. Ethan races through a ballroom in the Kremlin, which is actually in the fantastic Prague Castle. While we're filming in this beautiful historical location, surrounding tourists are more interested in the movie that's being made than the impressive structure, with many dying to get a sight of Tom. This shot was taken in a ballroom that is usually reserved for VIP parties. We were honored to be the first film ever to shoot in this room.

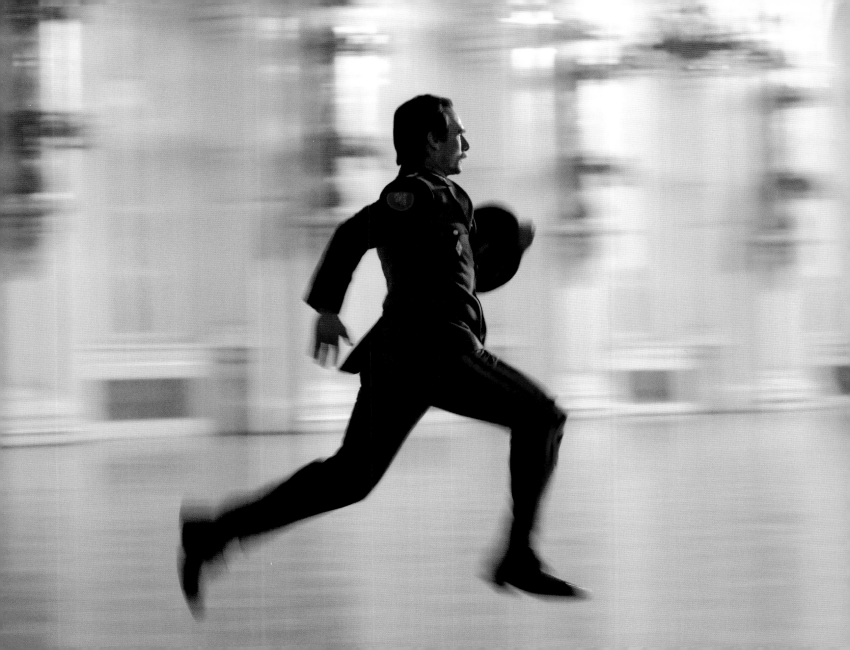

OCT 02 ˈ10 09:24:36

Brad shows Tom the route the camera will take for a shot that travels though a cobblestone street in the city. Wherever you shoot in Prague, you are surrounded by beautiful architecture.

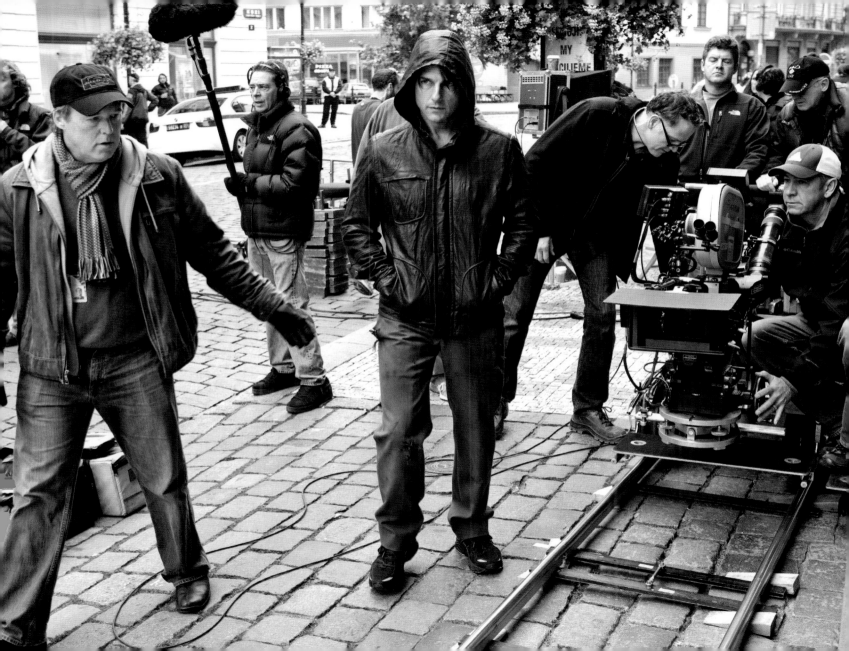

OCT 03 10 [09:51:39]

The art and set dressing departments did a wonderful job changing blocks in Prague into the backstreets of Moscow. Here, Ethan makes contact with the IMF team.

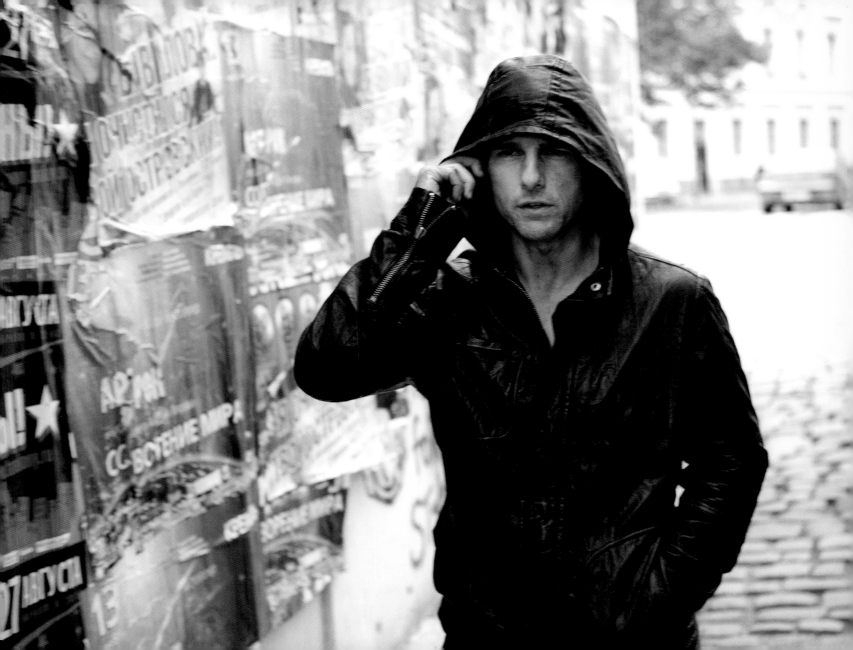

■ OCT 05 · 10 [13:35:04] [14:58:21]

Ethan is in a hospital when Russian agent Sidirov tells him he is in trouble. Ethan takes action immediately, jumping from the window. Tom really did jump from the window, but with wire rigs, which would become a staple on the *Mission* production.

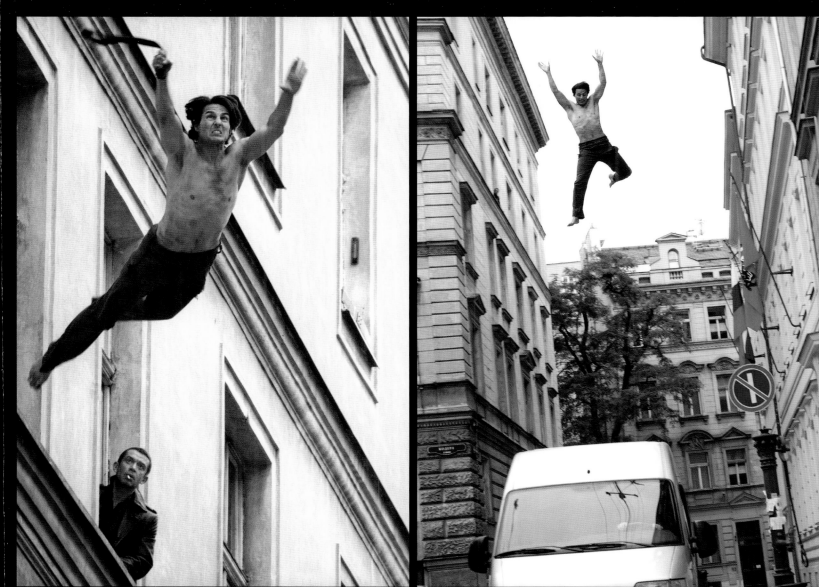

OCT 06 ˙10 [08:01:55]

Brad and Tom discuss how Ethan should land and escape after swinging down from the hospital window. This location was right outside a film school. Tom invited a class to observe us film. Both the students and their teacher watched. A free lesson.

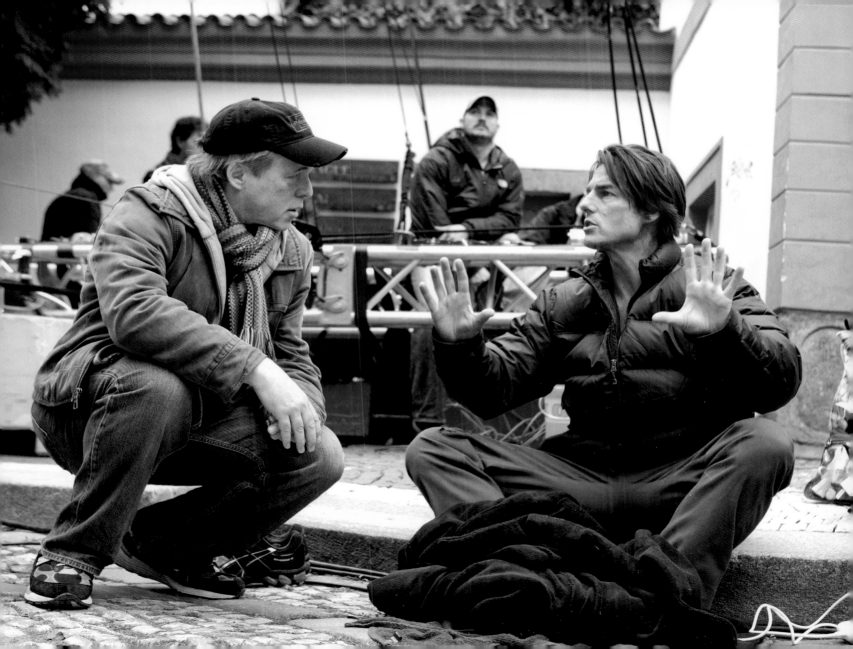

OCT 06 · 10 [14:52:26]

The next day of filming was devoted to getting through a lot of dialogue between Ethan and Sidirov. I shot this picture from a classroom window in a school opposite our shooting location. While I worked, there was a class going on. The children were very disciplined and managed to keep their eyes on the teacher while Tom Cruise was balancing on a window ledge across the street. As a thank-you for accommodating our filming, Tom posed for photos with each of them at the end of the day.

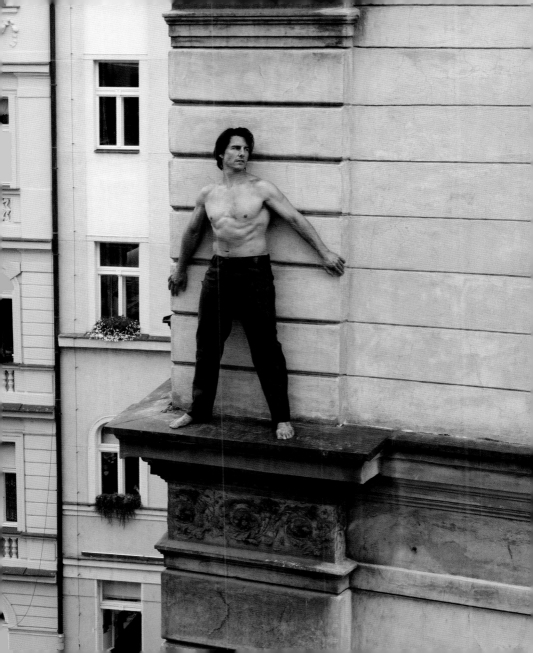

OCT 07 · 10 [12:05:02]

One of Russia's top actors, Vladimir Mashkov, plays the part of Sidirov, a Russian agent. He tells Ethan that he is in trouble—the authorities have found Ethan's Russian general uniform and disguise. Ethan escapes through a window. They say Vladimir is Russia's answer to George Clooney. I caught him sitting in a window relaxing between takes. Great light and a wonderful subject.

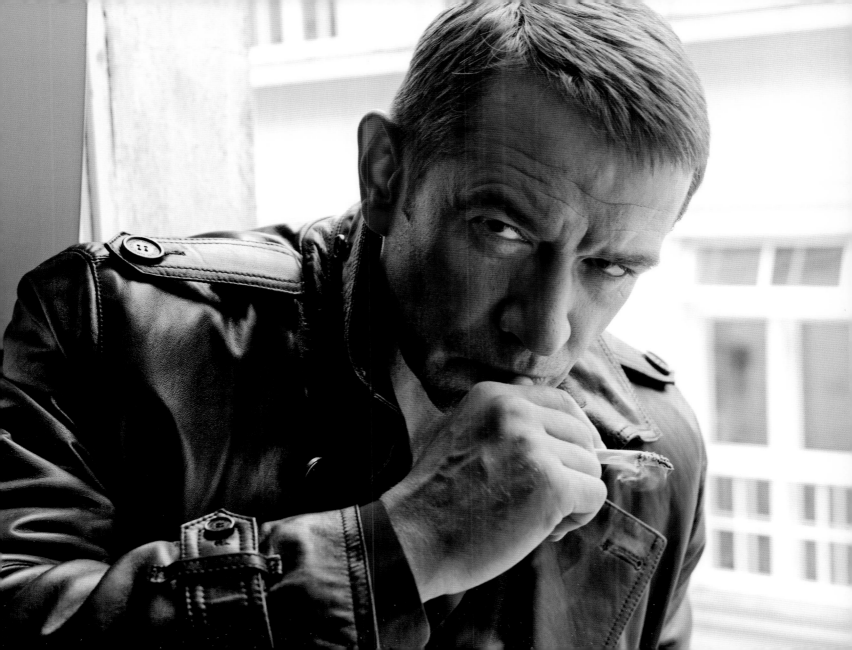

OCT 08 10 [13:01:26]

Ethan is incarcerated in Rankow Prison in Russia, and the IMF team helps break him out.

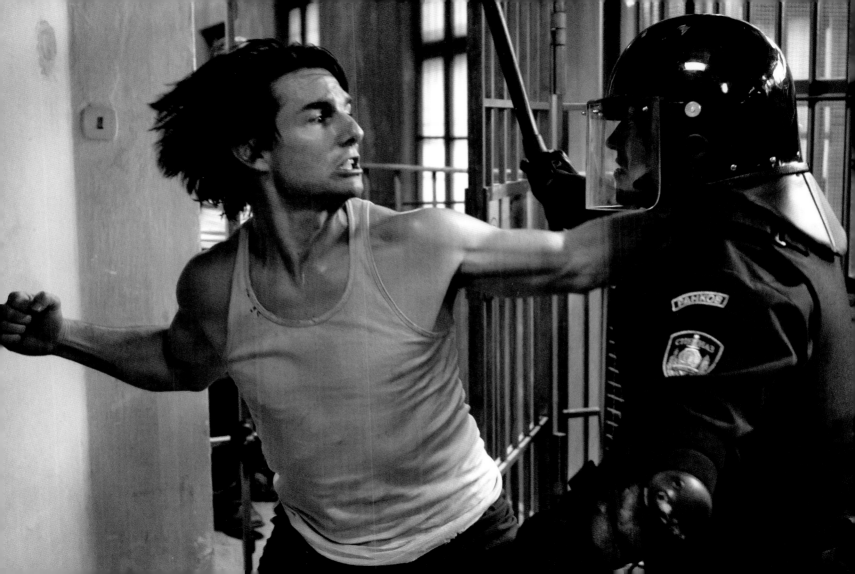

OCT 08 ' 10 [15:49:24]

Ethan, trying to get out of prison, comes face to face with a giant of a man. Fortunately, Ethan talks his way out of this one and manages to escape.

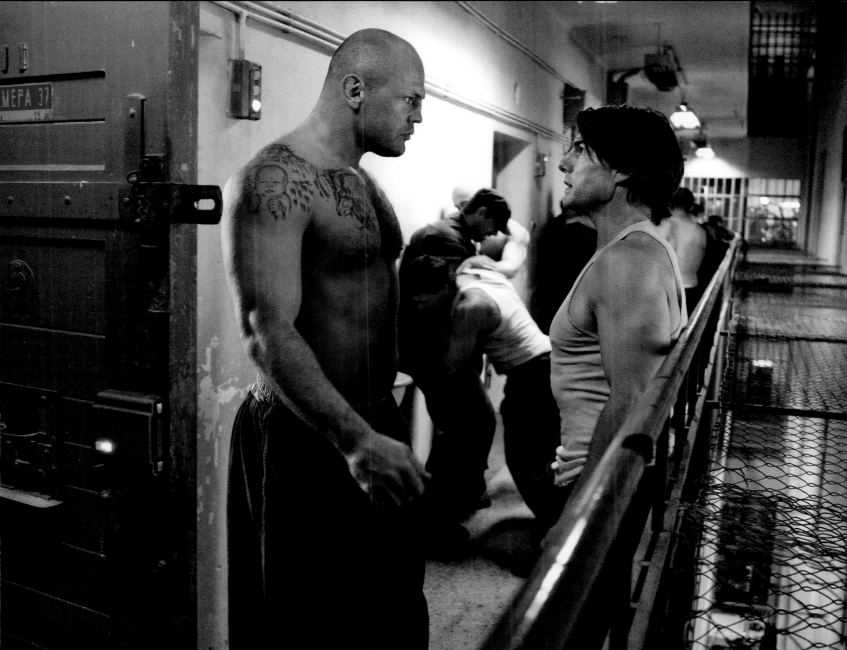

OCT 09 10 [08:07:48]

Ethan and Bogdan (Miraj Grbic), a fellow prisoner who fed information to Ethan, make good their escape as a riot starts in the prison. Mattresses were lit on fire and thrown from above for each take of this scene. We had to evacuate between each shot to let the smoke dissipate—not just for continuity, but for health reasons, too, since we were shooting in a very old prison with poor ventilation.

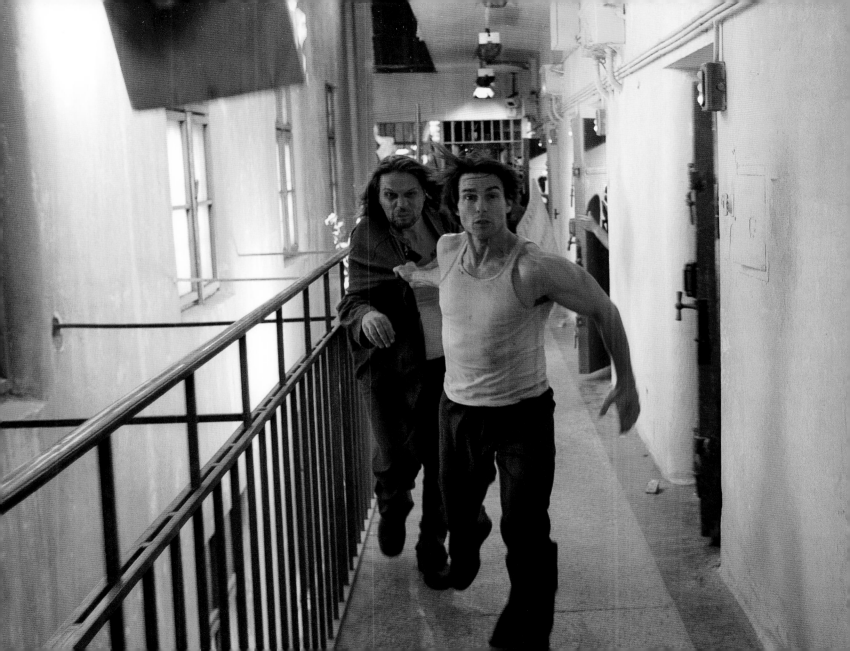

OCT 18 10 13:55:42

Josh Holloway films a stunt in which his character, Trevor Hanaway, another IMF agent, drops from a building while aiming his gun back at his pursuers. He then throws his pack and it inflates into a landing pad that breaks his fall. This was not the best part of the Prague shoot. It was a cold, gray day, and the location was wedged between a railway on one side and a freeway on the other. Drivers passing by paid no attention to a man jumping off a roof and shooting into the air.

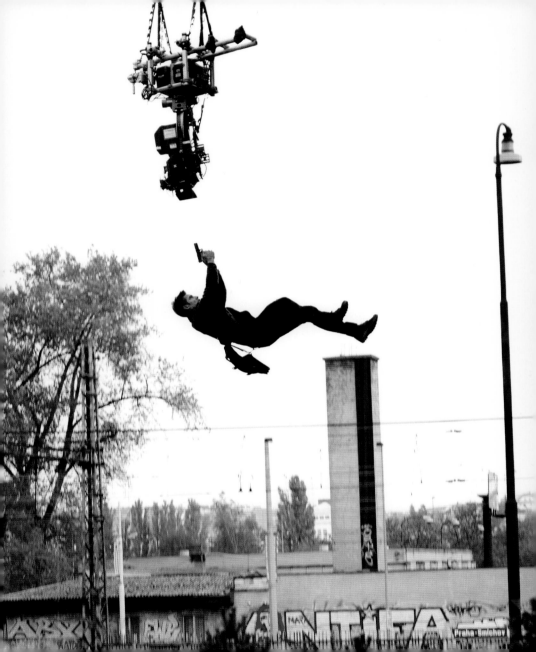

OCT 19 10 [10:20:01]

This is the same location by the railway and freeway as the previous day, with the same cold, gray weather. Josh runs across a rooftop while being chased by bad guys. The oversized camera is an IMAX camera, which was used to shoot much of *Mission: Impossible – Ghost Protocol*.

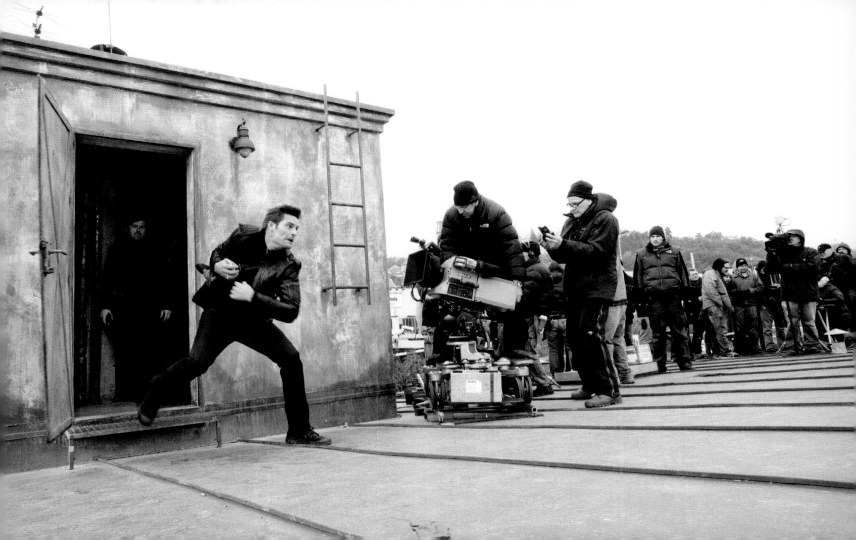

OCT 20 · 10 [13:25:31]

One bright moment on what was otherwise another cold, gray day. She's beautiful, she's French, she's charming, she has piercing blue eyes, and she's a killer. This is Sabine Moreau, played by Léa Seydoux.

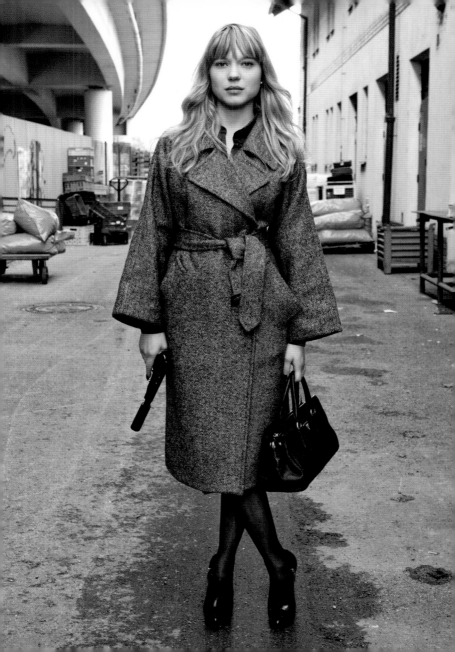

OCT 20 · 10 [13:44:22]

One of the fun parts of shooting films is that one often gets the opportunity to take portraits of actors away from the movie camera. Josh Holloway and I hit it off immediately, and I took several candid pictures of him while we were in Prague. He is a photogenic guy and very relaxed. We had a lot of fun.

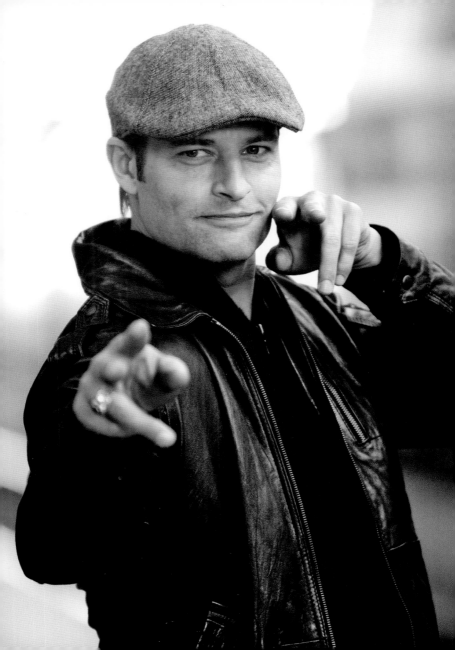

OCT 21 ' 10 [12:34:24]

A romantic setting for a hurried lunch and a candid moment: Léa Seydoux eats a boxed lunch on a cold railway platform in Prague.

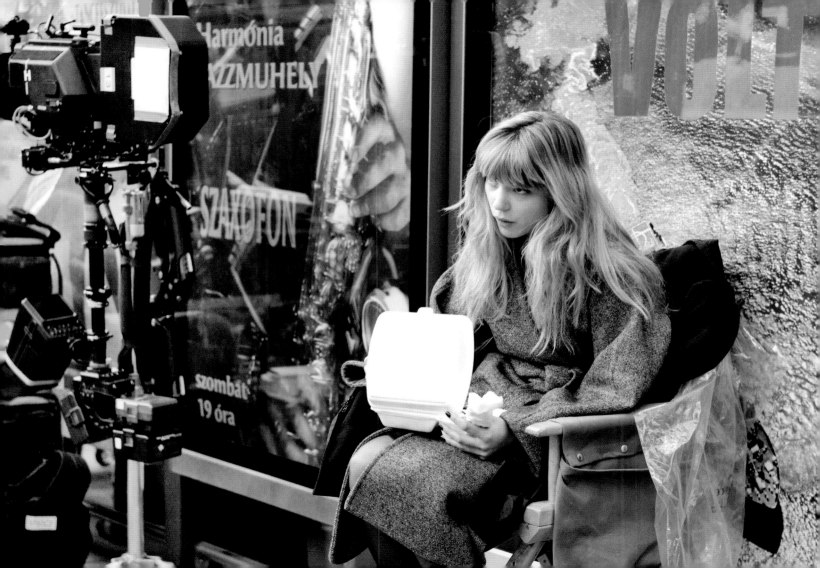

OCT 22 ˙10 ⌜ 11:50:22 ⌝

I saw two cameras side by side—industry workhorse Panavision Reflex on the left, the IMAX camera on the right—and thought to shoot Josh Holloway in between them. He's always willing to get in there. Despite everything going on this shot, his eyes still dominate the frame.

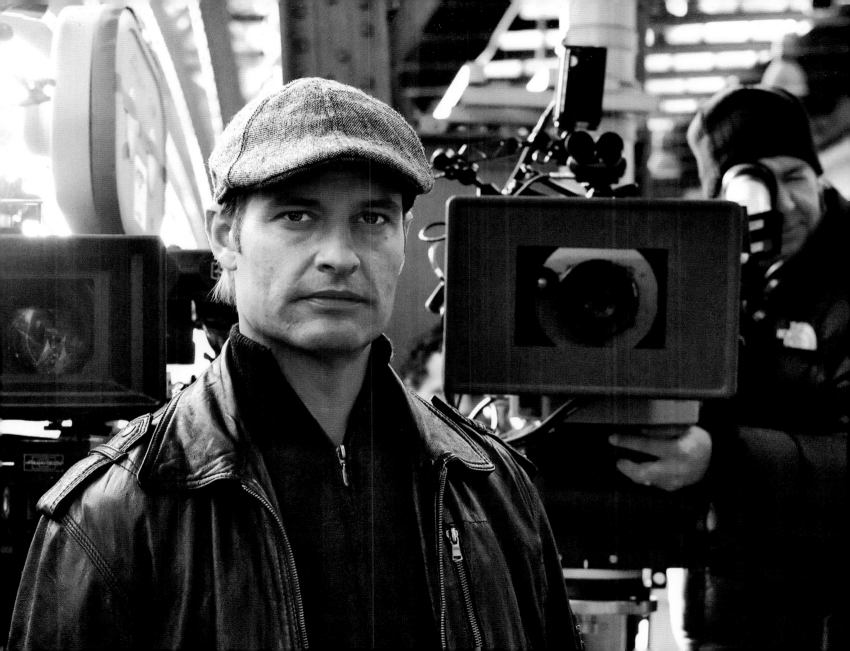

OCT 29 – NOV 20 2010

DUBAI

OCT 29 '10 [14:47:57]

To get this shot, I also had to hang out of the Burj Khalifa on the 164th floor where we were shooting, looking straight down. I did have a harness with attachments for my camera, filters, and hoods. Before I went up there, I told Tom that I would be above him during his climb. Twice he looked right in the lens.

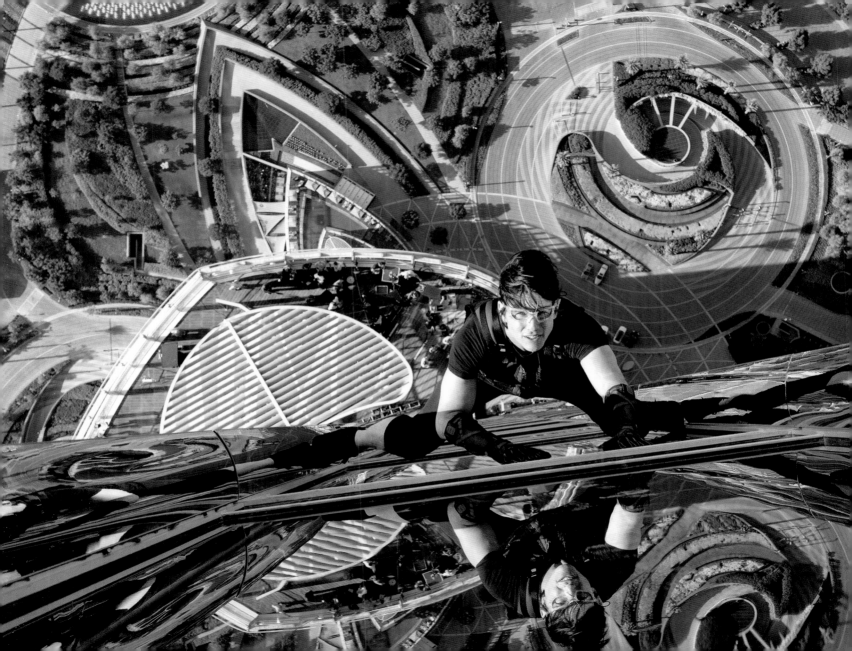

▪ OCT 30 · 10 [13:36:25]

High above the city of Dubai, upon the completion of another spectacular shot, Tom and Brad share a moment of triumph.

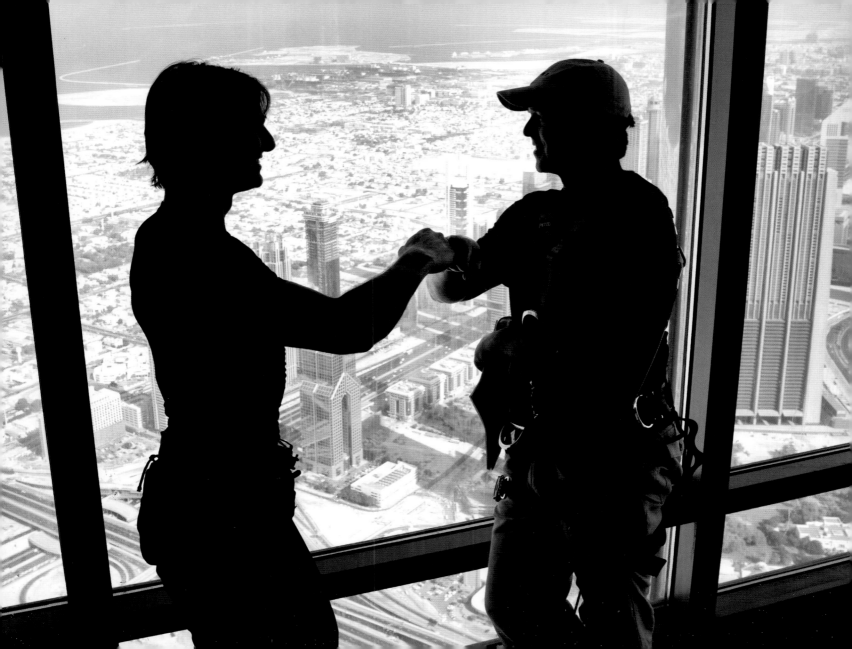

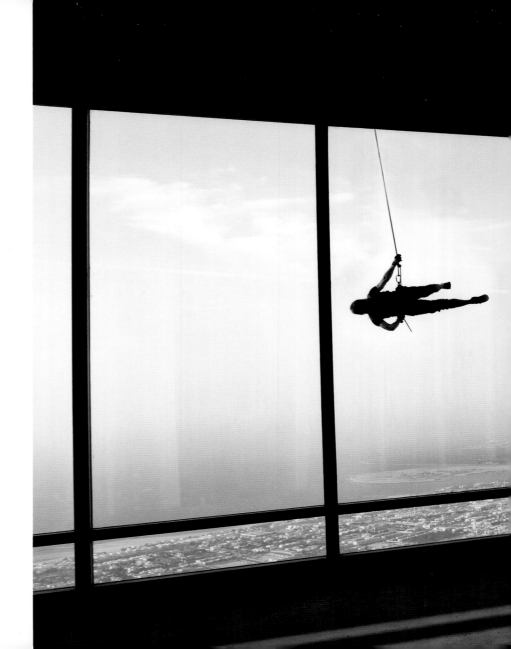

OCT 30 · 10 [15:43:41]

I found an empty floor somewhere around the 170 mark and decided to hunker down. It was a good choice, as I managed to capture Tom swinging around the Burj Khalifa being chased by our camera helicopter, piloted by Marc Wolff.

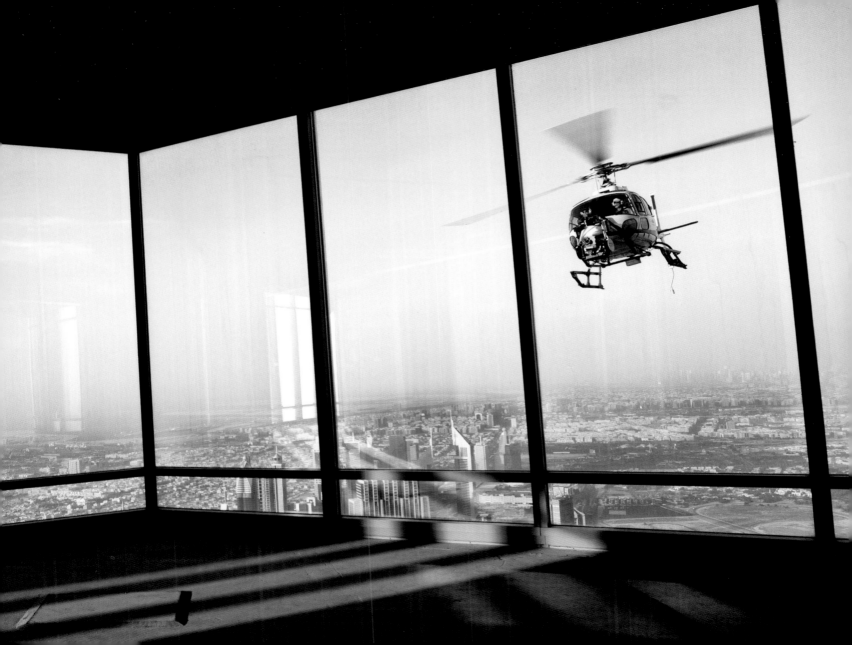

OCT 31 ' 10 09:06:28

We took a day away from the Burj Khalifa and went on a trip out into the desert outside Dubai. I could not resist sending this photo to Tom at the end of the day with the caption, "Star transport and crew transport."

OCT 31 '10 13:59:03

All the actors and camera crew were packed into a jeep for most of our day out in the hot desert. Here is Jeremy Renner, who plays Brandt, a new member of the IMF team.

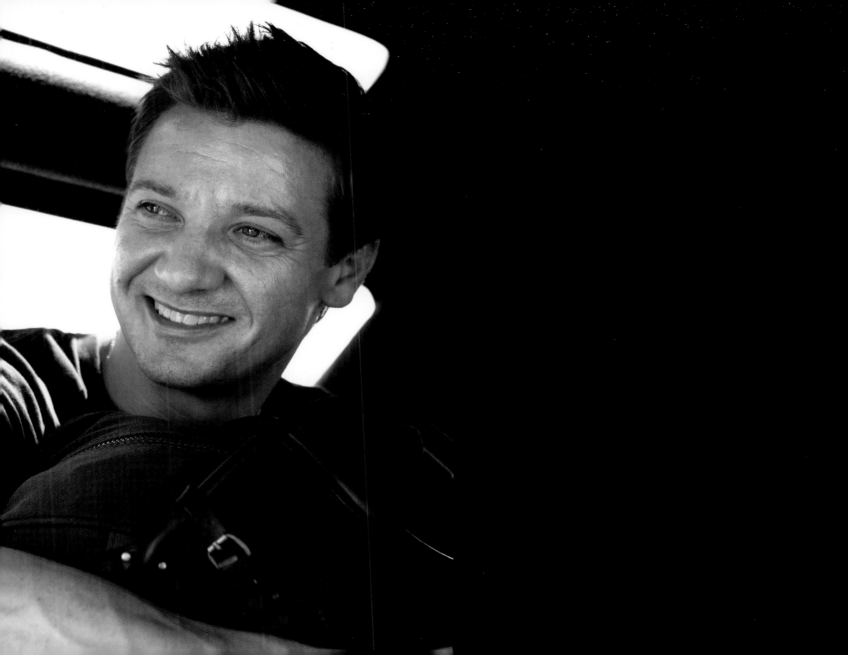

■ NOV 02 10 [07:26:37]

Director of photography Robert Elswit checks a shot. The IMAX camera in front of him will extend out the window to shoot straight down. You can clearly see the lifeline that secures us. A very diligent team of safety officers from Paramount Pictures kept us safe during this whole venture.

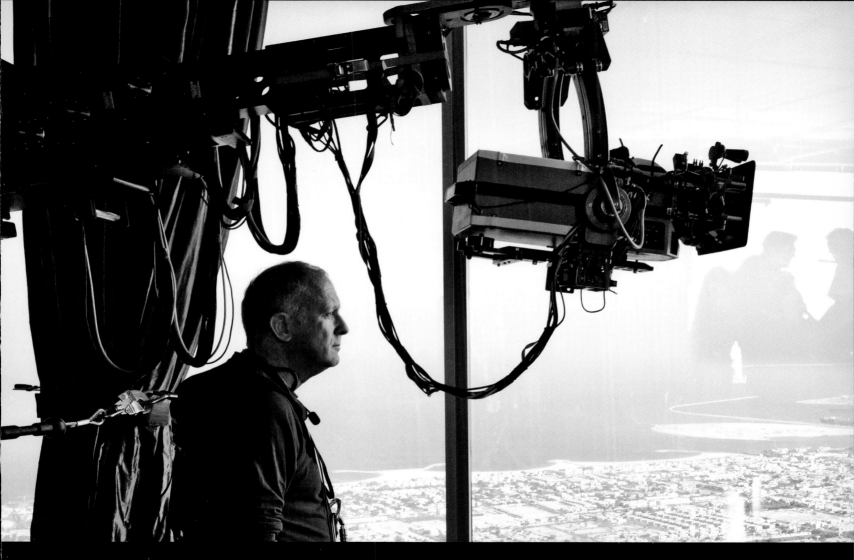

NOV 02 · 10 [09:08:18]

Hanging out between takes, Tom shares a joke with Jeremy Renner. I was constantly amazed by how comfortable Tom seemed to be out there on the line. You have to have a lot of trust and confidence in the wire guys and the wire itself. Jeremy was also wired in.

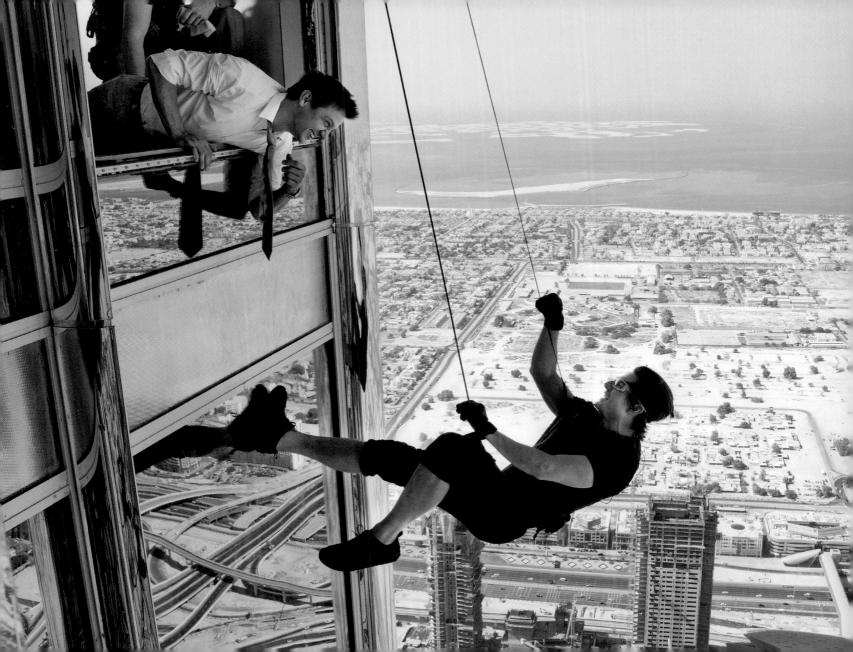

NOV 02 10 [09:49:02]

The IMAX camera looks over Tom's shoulder as he tests the adhesion of his gloves on the glass surface of the Burj's exterior. The strange-looking tube at the top is a giant wind machine placed floors above to simulate a wind and dust storm that will approach while Ethan climbs the building.

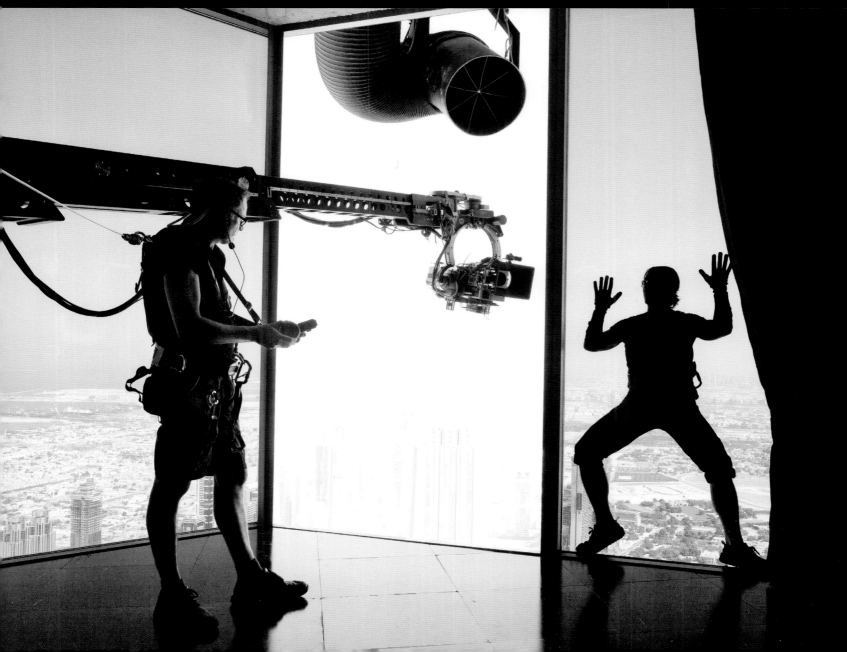

NOV 04 · 10 [11:03:02]

Two massive windowpanes had been taken out of the Burj Khalifa on the 164th floor. Two cameras filled the holes completely; one was on a crane. To get the shot in the film where Ethan crashes through the window, Tom, hanging on a cable, had to run the width of the building to gain momentum and then jump out into the void and swing around in an arc to come through the window opening, which would later be filled in with visual effects. ■ As much as I tried and cajoled, there was no way for me to get this shot while they were filming. "Cut, print it," came the call from Brad. "Bring Tom in." One camera pulled back and I seized the moment, filling the spot. "Tom" I shouted, "do it again, for me." Without any hesitation, he ran along the building and leapt once again into the air, swinging out with the world behind him. I have been shooting for movies most of my life and have never yet worked with an actor who would, without question, perform a stunt like that for a still photo. Thank you, Tom.

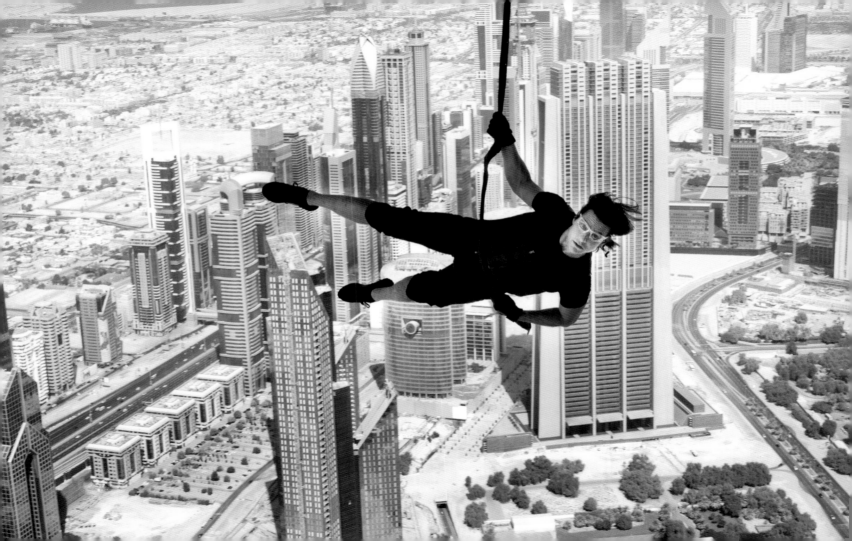

NOV 04 · 10 [12:38:15]

Climbing consultant David Schultz helps lower Tom into a precise position for the camera. Gregg Smrz, our stunt coordinator, watches over the operation.

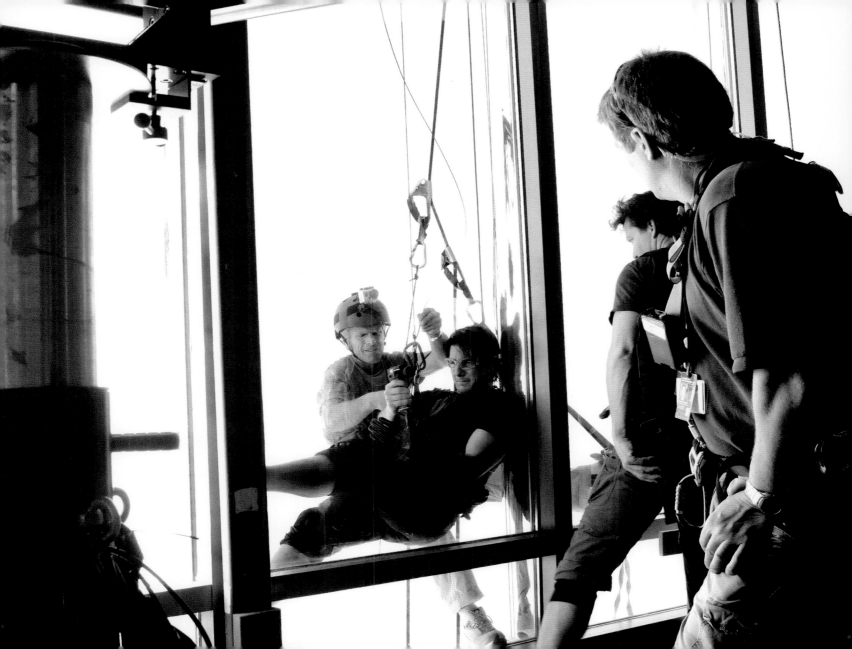

NOV 11 · 10 [12:45:11]

Our lengthy chase sequence starts in Dubai and will take us into a dust storm and through many different locations. The first day of shooting, we did a dust storm test for this sequence. From a comfortable distance, I shot Tom facing into a giant wind machine that blew mashed cardboard at him. He spotted me and called for me to get closer and shoot some pictures. I jumped straight in there with him. Thank you to the medics who washed out my eyes afterwards. And good instincts, Tom: The pictures turned out well.

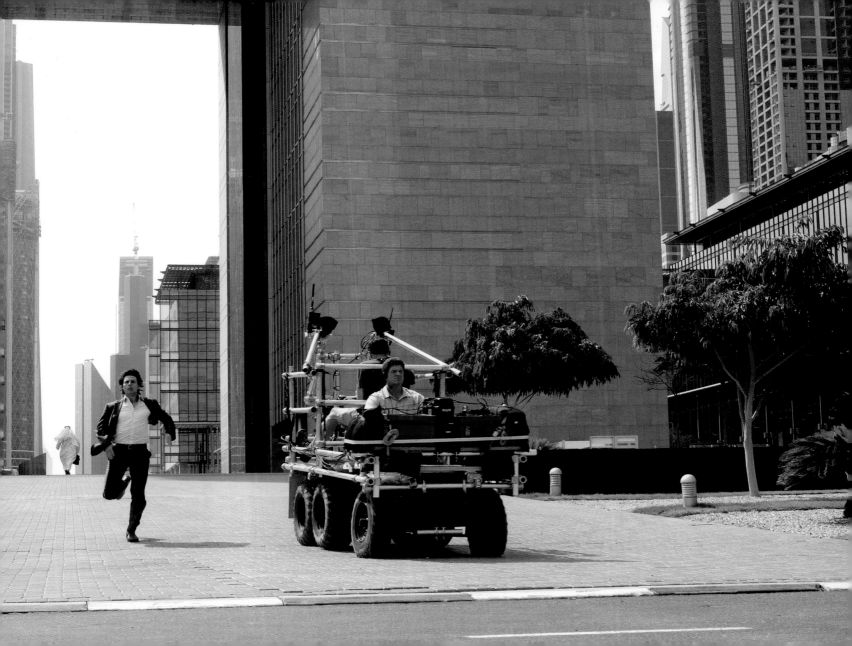

NOV 12 '10 13:10:23

A six-wheel all-terrain vehicle rigged to carry the IMAX camera and assistant chases actors through the simulated dust storm.

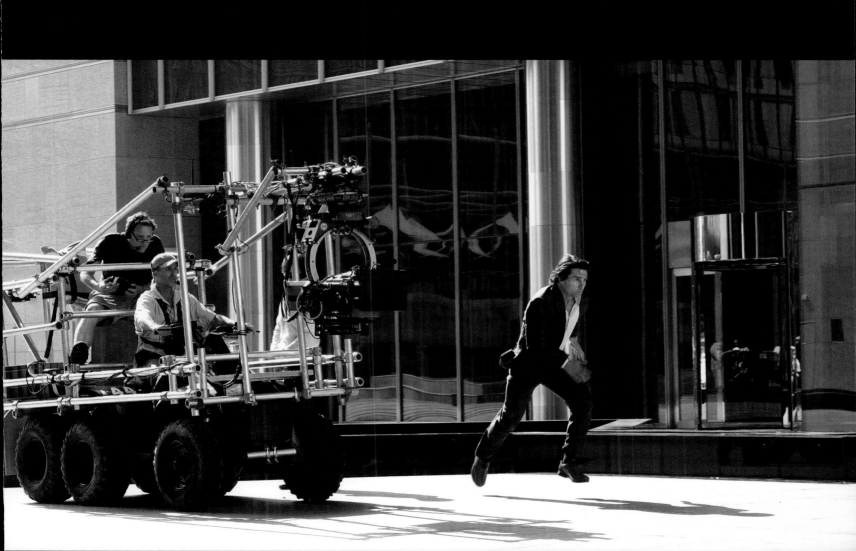

NOV 13 '10 15:49:48

Director Brad Bird explains the beginning of the chase sequence to Tom. It starts at the base of the Burj Khalifa and moves out into the streets.

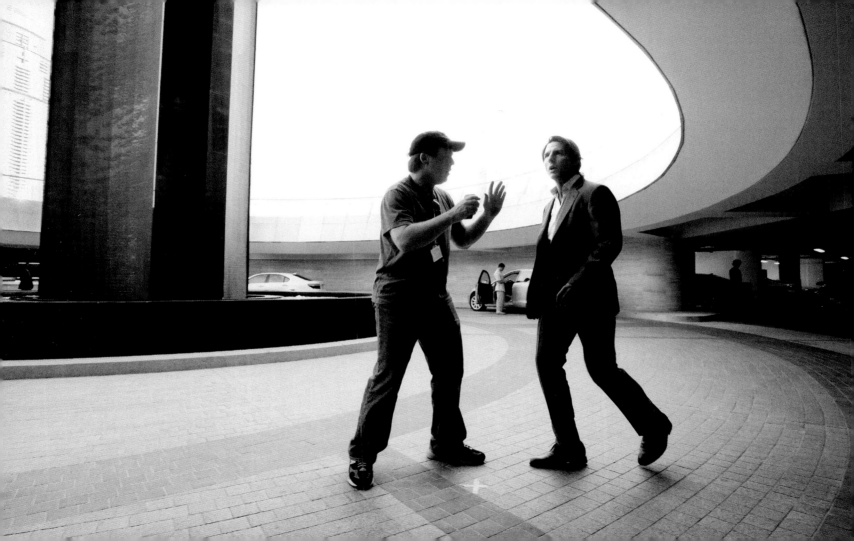

NOV 15 · 10 [07:03:50]

An assistant director uses an air horn to give an action cue to Tom amidst the simulated dust storm. Although visibility was extremely limited, he had to crash the car very close to camera. When you're shooting in a special effects dust storm, you have to wear a mask, goggles, and anything else you can throw on to protect yourself. What sort of approach does a stills photographer take in such conditions? You pick a spot to shoot from, focus, and hope for the best.

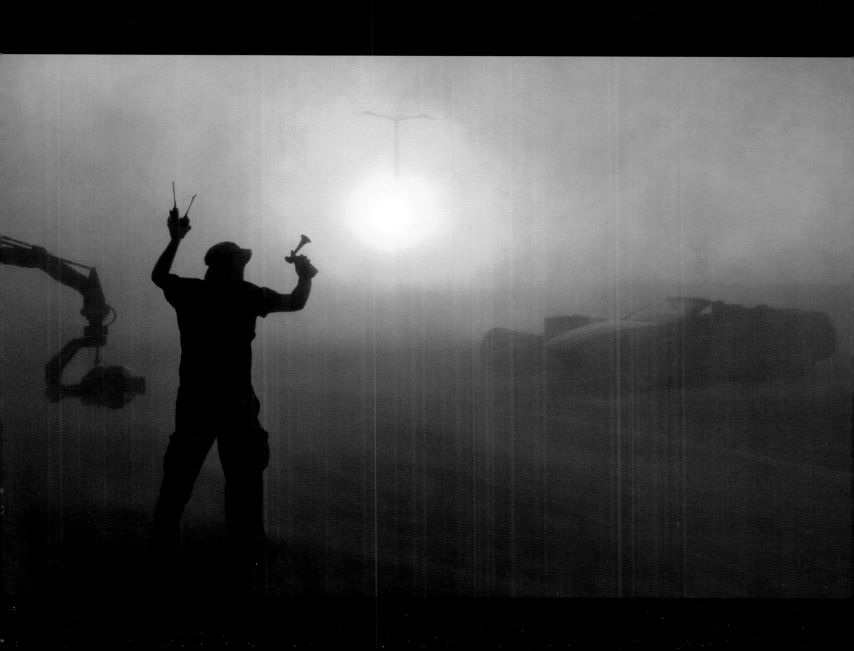

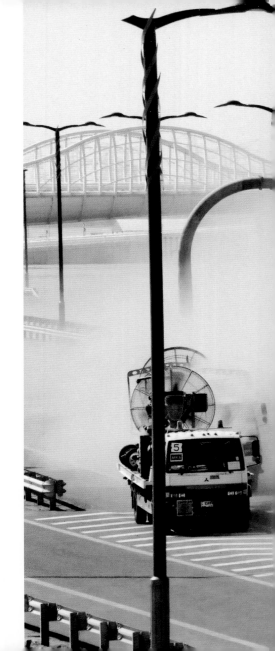

NOV 16·10 [11:10:52]

A fleet of trucks carries huge wind machines and special effects technicians. They blast shredded cardboard through the machines to create the dust storm effect. I hated the man-made dust, but these behemoths driving in a convoy were a very impressive sight. The funny thing is, we had to shut down once while filming this sequence when a real dust storm started.

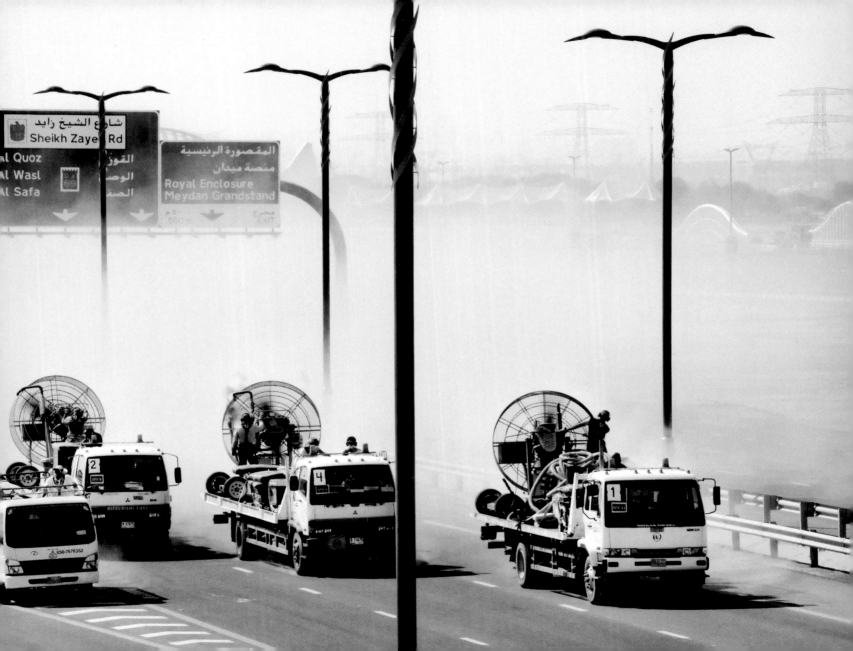

NOV 16 '10 [16:30:25]

At the end of the dust storm chase, Ethan stands on the Royal Bridge that leads from the main road in Dubai to the Meydan Racecourse. The bridge is normally reserved exclusively for the royal family of Dubai, the Al Maktoums, but they graciously let us use it to film this sequence.

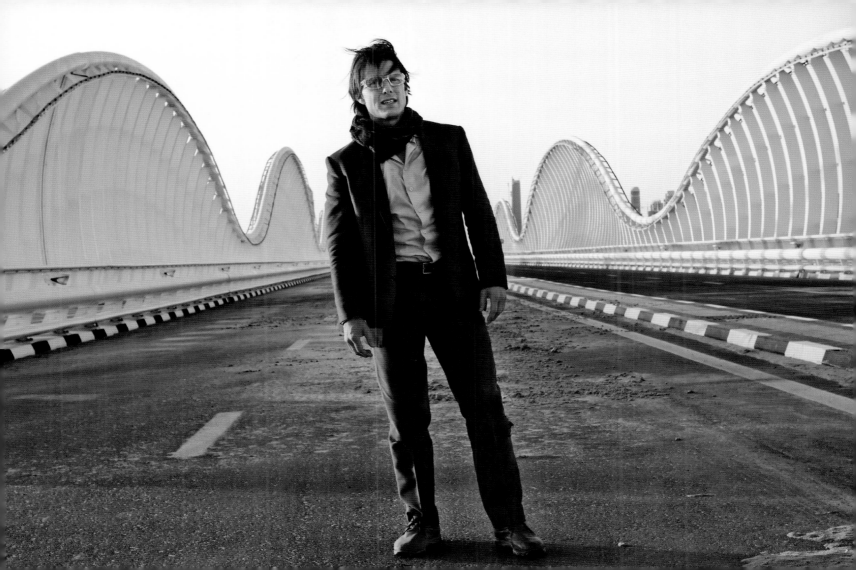

NOV 17 10 [10:06:51]

We built a section of the Royal Bridge at Dubai's Meydan Racecourse to stage the crash of Ethan's car, which rolled and flew through the air, eventually landing upside down.

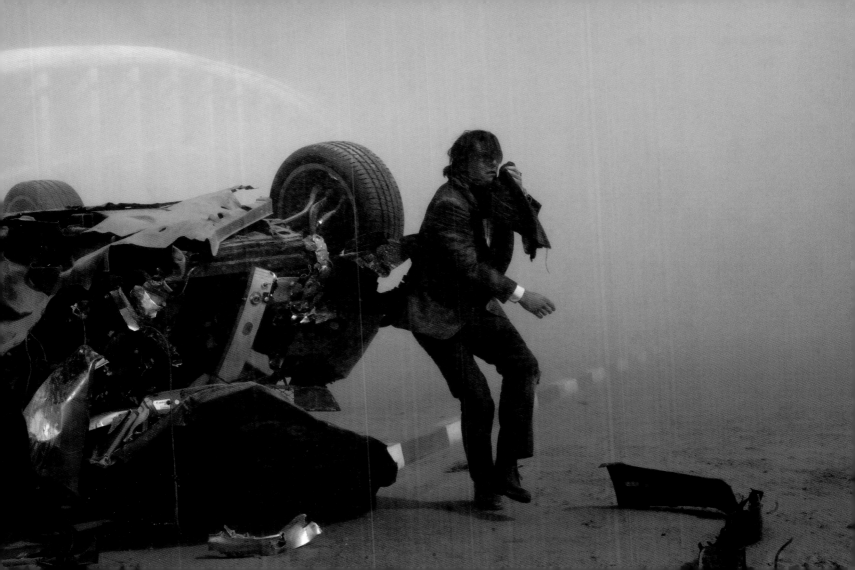

NOV 17 '10 [16:46:36]

The Royal Bridge was a fitting location to shoot a picture of our "top team." From left to right are executive producer Jeffrey Chernov, director Brad Bird, Tom Cruise, producer Bryan Burk, co-producer Tommy Harper, and co-producer Tom Peitzman.

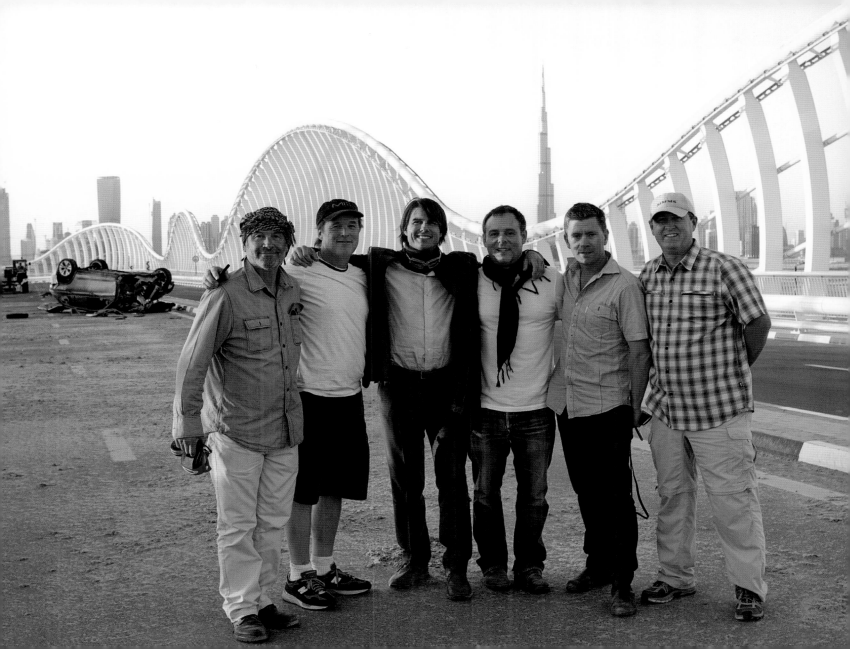

NOV 18 10 [14:07:55]

Tom does brush up nicely. This is one of my favorite shots of Tom as Ethan. I heard Mrs. Cruise also liked it.

NOV 19 10 [13:00:02]

Ethan and Jane (Paula Patton) arrive at a party that takes place at a sumptuous new hotel on one of the Palm Islands in the Dubai archipelago. Ethan's car is the BMW Vision EfficientDynamics, a lightweight sports car powered by a plug-in 356-horsepower hybrid drive train. Look for it sometime in the not-too-distant future.

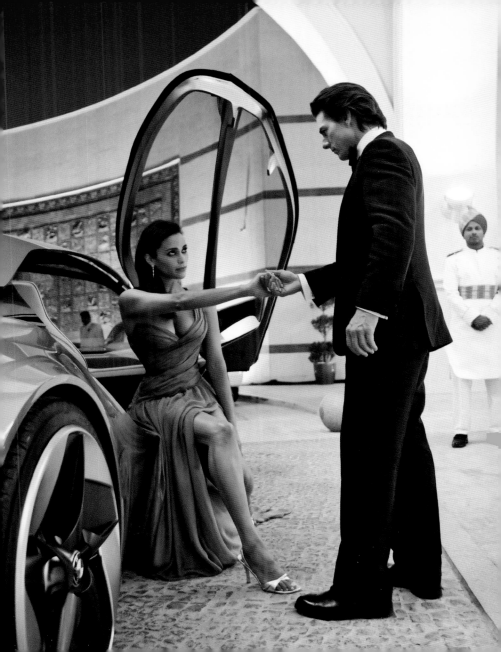

NOV 19 10 [15:24:06]

Jane (Paula Patton) gets friendly with Brij Nath (Anil Kapoor). Nath has something the IMF team needs, and Jane can be very persuasive.

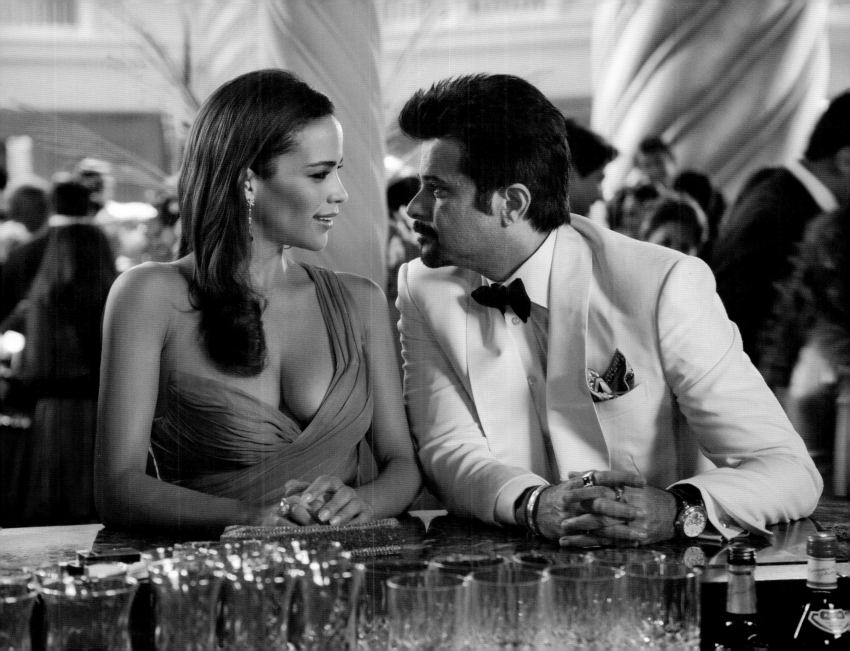

NOV 20 10 15:02:34

We built our own street market in the alleyways of Dubai for another segment of the dust storm chase. By this time, I was beginning to think the dust storm shoot would continue for the duration of our time in Dubai. I was right: It pretty much did.

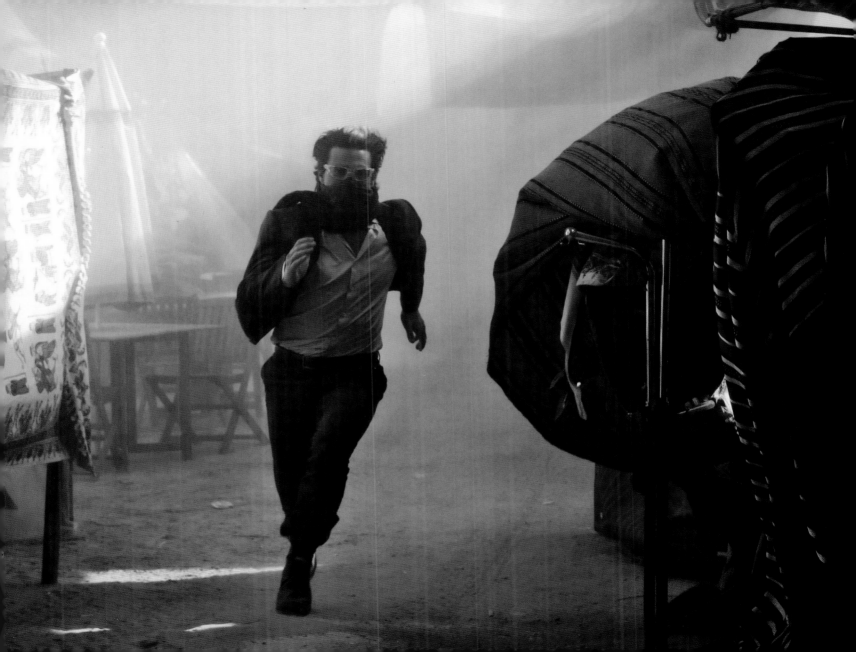

DEC 08 2010 – MAR 17 2011

VANCOUVER

DEC 08 · 10 [11:20:43]

Ethan is alone in the Dubai safe house while the IMF team waits in the adjacent room. This room was so small there wasn't enough space for the movie camera and me, so I patiently waited for the moment when the crew pulled their camera and I could set my own shot. In the film, Ethan is on the phone with the gun nearby on the sink. I knew that the gun would feature in the ensuing scene, so I took a little license and asked Tom to use the gun instead of the phone.

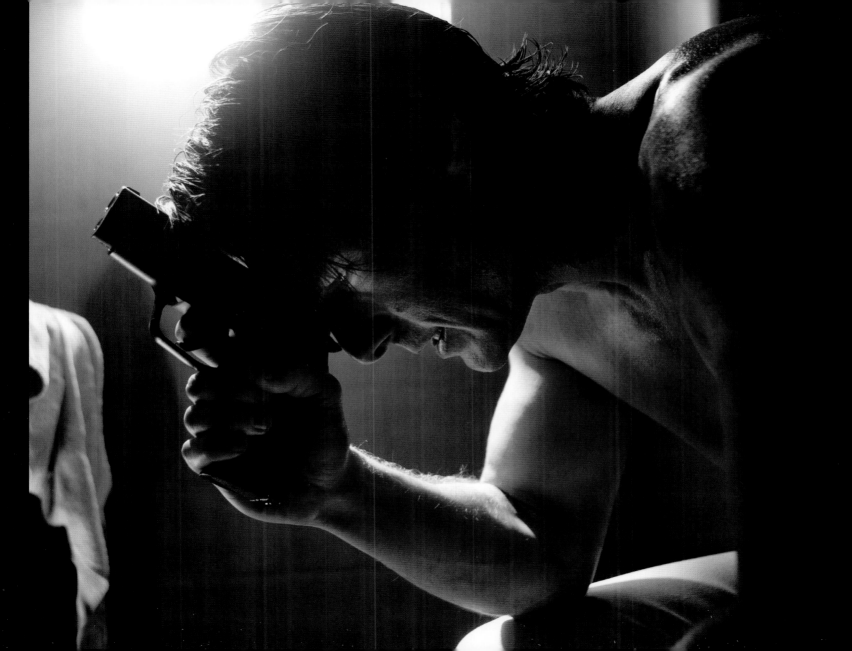

DEC 08 10 [13:15:09]

Ethan berates the team in the Dubai safe house. They all see Brandt's skills. Ethan leaves and Brandt (Jeremy Renner) explains Ethan's backstory. This set was beautifully lit, with lots of shafts of light. Once filming was done, another moment was set aside for me to set up a still-photograph interpretation of the scene.

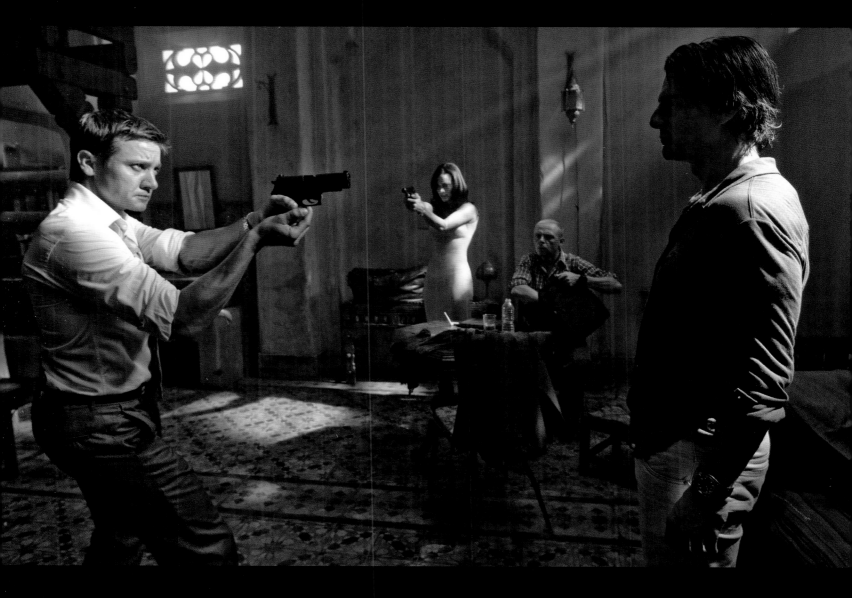

■ JAN 03 · 11 ⌜ 10:42:15 ⌝

This is that ubiquitous moment in all *Mission: Impossible* movies when the adventure begins. Ethan gets the call and hears those immortal words: "Your mission, should you choose to accept it . . . " And, of course, the phone self-destructs.

JAN 03 · 11 [13:08:41]

A park in Russia (which is really Vancouver). Ethan has just received the assignment. It was a very, very cold day, and we were all still thin-blooded from our time in Dubai. The heater on the left was there to help us try to take the chill off.

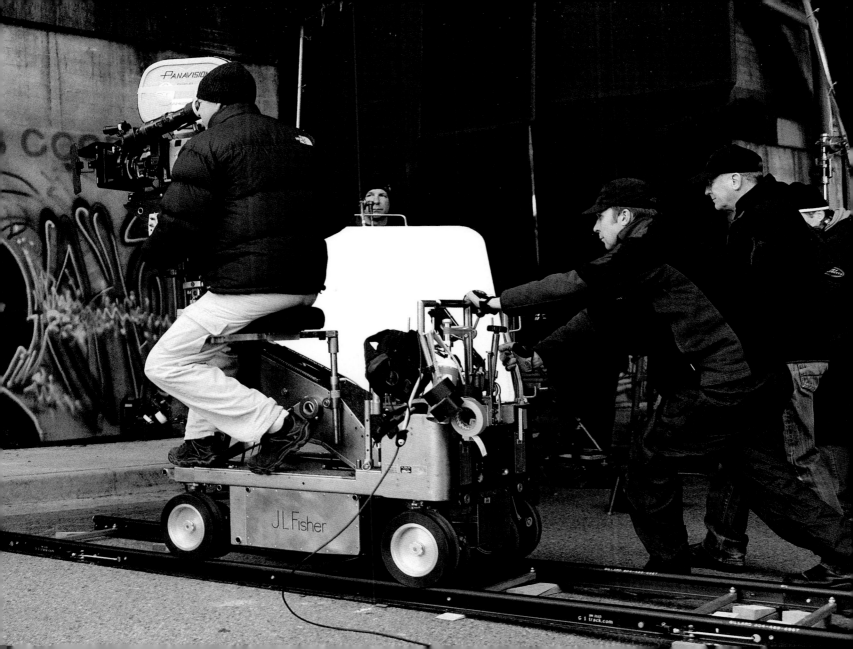

JAN 05 · 11 [08:58:32]

Jane (Paula Patton) sets the explosives that will open up a hole in the floor of the Rankow Prison through which Ethan and Bogdan will escape. This is a "break all the rules" picture. Part of the fun of being a photographer on movies is that sometimes you can play with the traditional guidelines. Have fun and, bingo, sometimes it works.

JAN 06 · 11 [14:24:35]

Sometimes, just sometimes, things go spectacularly right. Ethan is standing by the window in this suite ostensibly in the Burj Khalifa. Benji (Simon Pegg) throws the suction glove at the window to show Ethan how well it sticks. Simon had to throw the glove perfectly, right in front of the lens. Things went well in rehearsal, and, with cameras rolling, it took only a few takes.

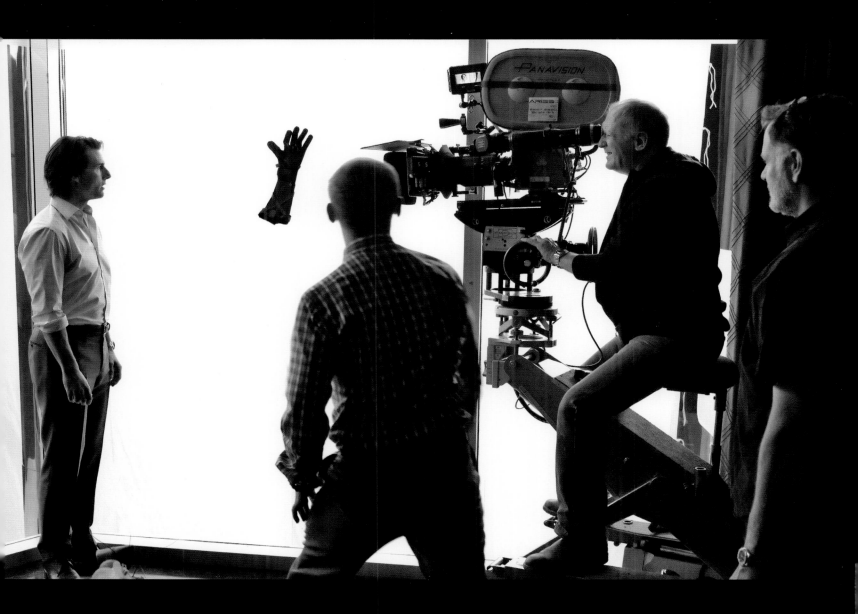

JAN 07 ' 11 20:58:25

This is downtown Vancouver at night, which we turned into a street outside a radio station in Mumbai. In this shot, the cameras are rolling while Tom waits for the background action to start. He'll then run though traffic in pursuit of Hendricks, the film's true villain, and follow him into the radio station. This was the first shot in a long series that added up to a hard night's work.

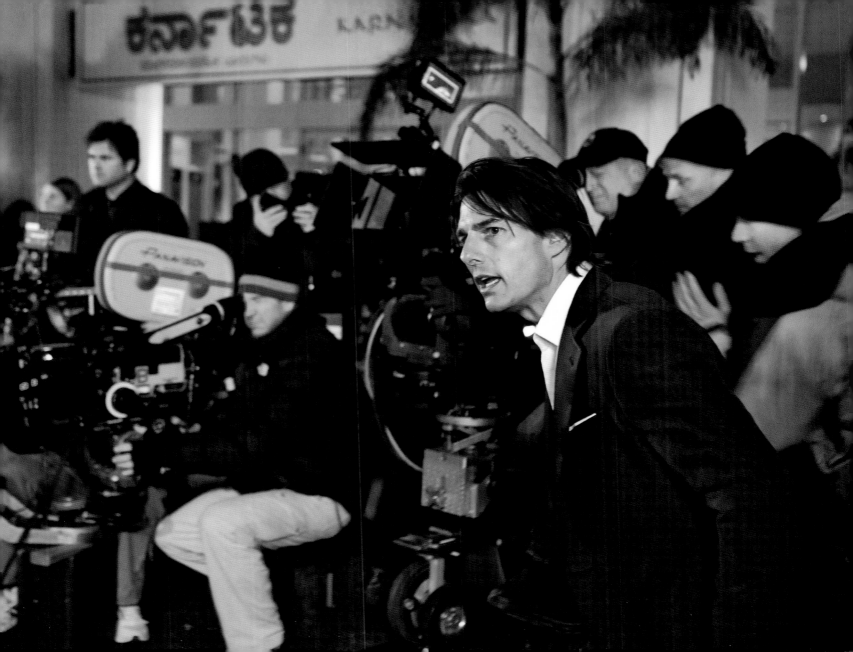

JAN 07 · 11 [22:29:31]

In this sequence, Ethan chases Hendricks into a radio station building in Mumbai, leading to their climactic fight in a parking garage. Vancouver, as is the case with many other cities that are amenable to movie production, often has to become somewhere else. For *Mission: Impossible – Ghost Protocol*, Vancouver became Moscow and then Mumbai and then even Dubai on occasion. To create the look of Mumbai, we took over a section of Vancouver's downtown and put up a lot of dressing, including Indian vehicles and lots of local extras who may well have immigrated to Canada from Mumbai. The *Starsky and Hutch* hood-slide move was a last-minute stunt that Tom added to the shot.

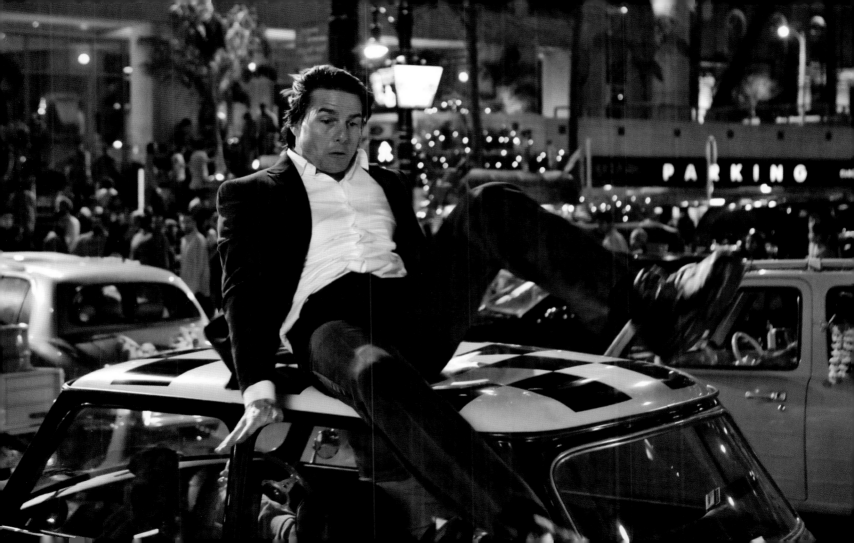

JAN 18 ' 11 17:33:24

Room 118G in the Burj Khalifa. Ethan and Brandt (Jeremy Renner) meet with Moreau (Léa Seydoux) to work out their end of the operation.

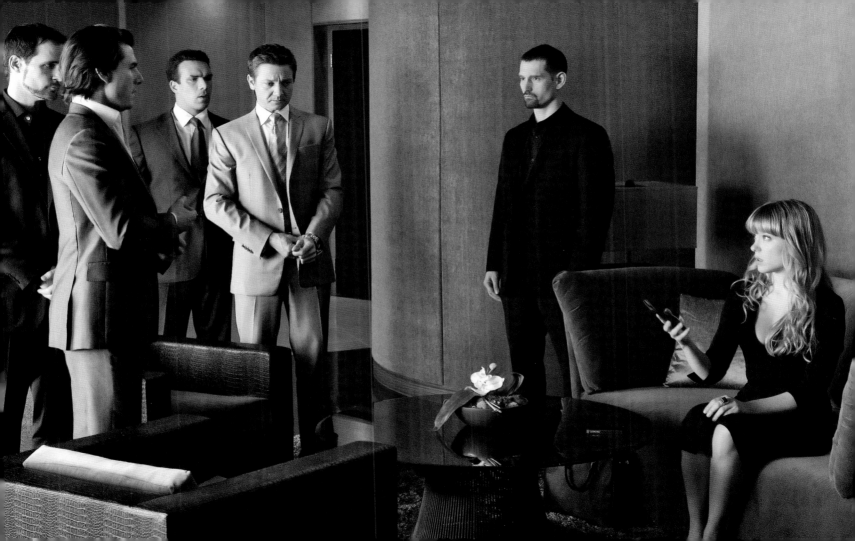

JAN 19 ˈ11 [07:57:26]

You can almost feel the creative thought process happening, with so many minds working away to figure out just how to shoot a scene. This type of scenario happened many times a day, but rarely do you capture so many contemplating the same thing in one shot.

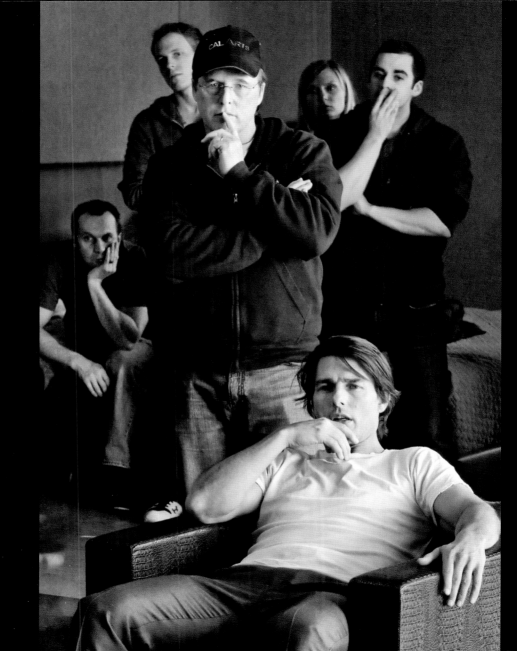

JAN 20 ' 11 09:07:02

I have always loved photographing silhouettes. Brad and Tom both intuited why I was hanging around them while I was trying to get this shot, so they helped create the moment by positioning their heads to give me perfect profiles. I am sure they both had a mental image of what I was after.

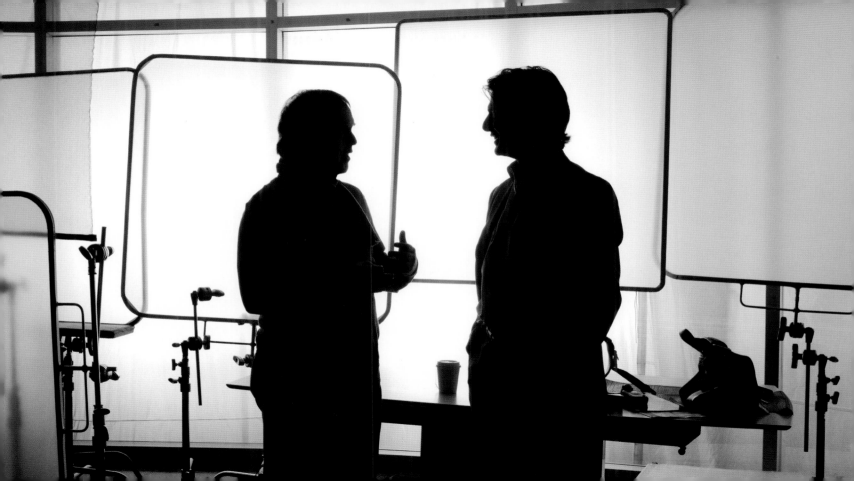

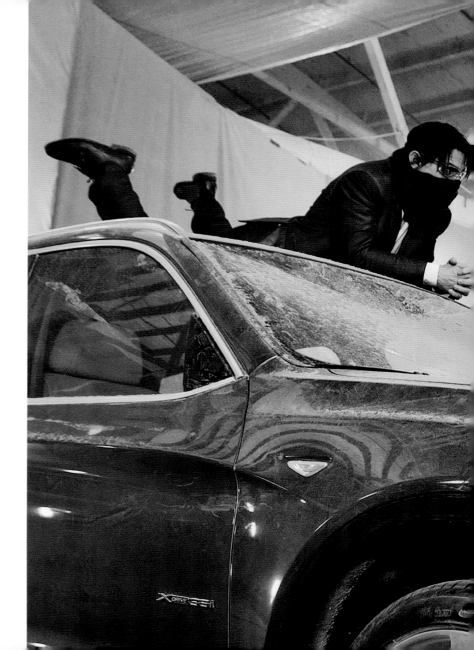

JAN 25 | 11 [08:58:46]

Second unit director Dan Bradley runs through a scene
with Tom. It's that dust storm again, which followed us
all the way from Dubai to a barn in British Columbia.

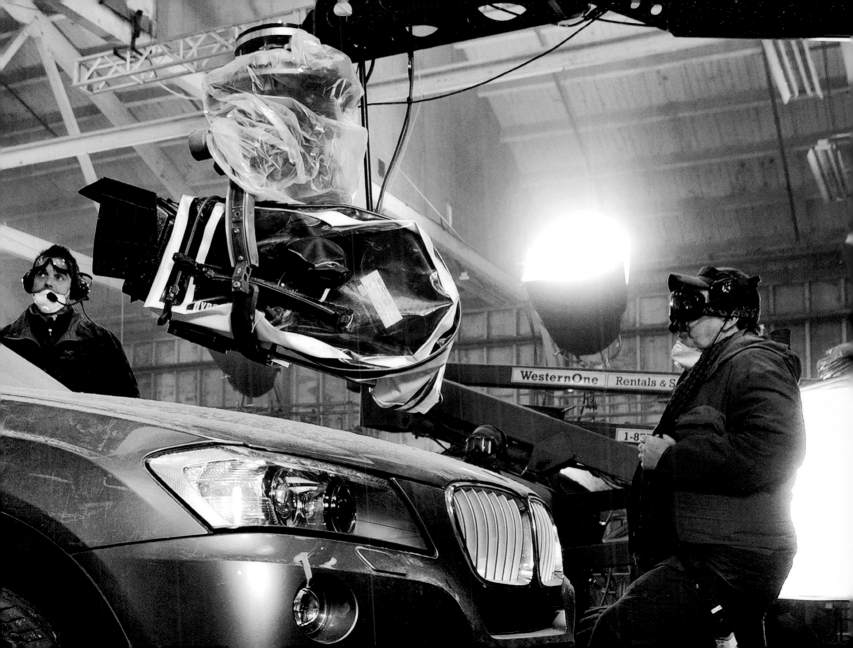

JAN 25 '11 10:25:14

This is pretty much what the shot in the film looks like. Outside the frame, wind machines are blowing dust all around. The sand was blinding!

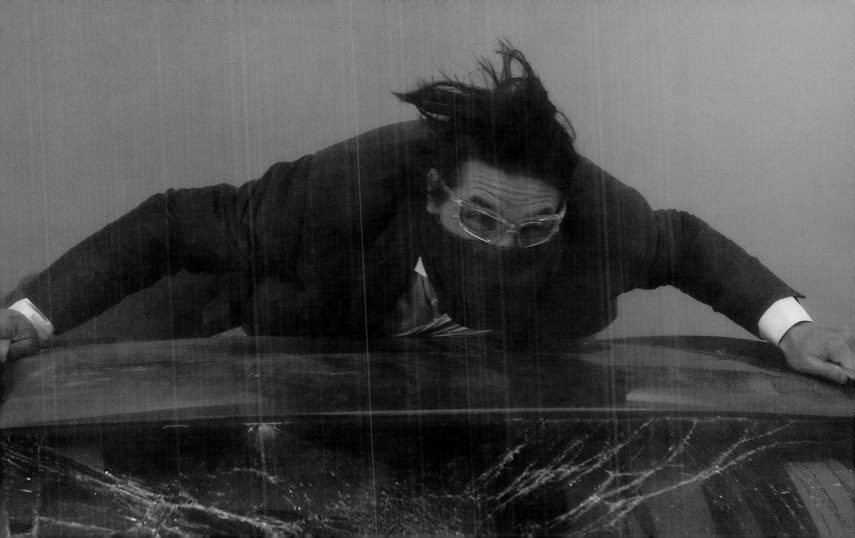

JAN 27 ' 11 [12:42:37]

These are special effects rigs outfitted with high-powered wind machines that create the dust storm. The pipes in the front spew the cardboard dust into the wind created by the fans.

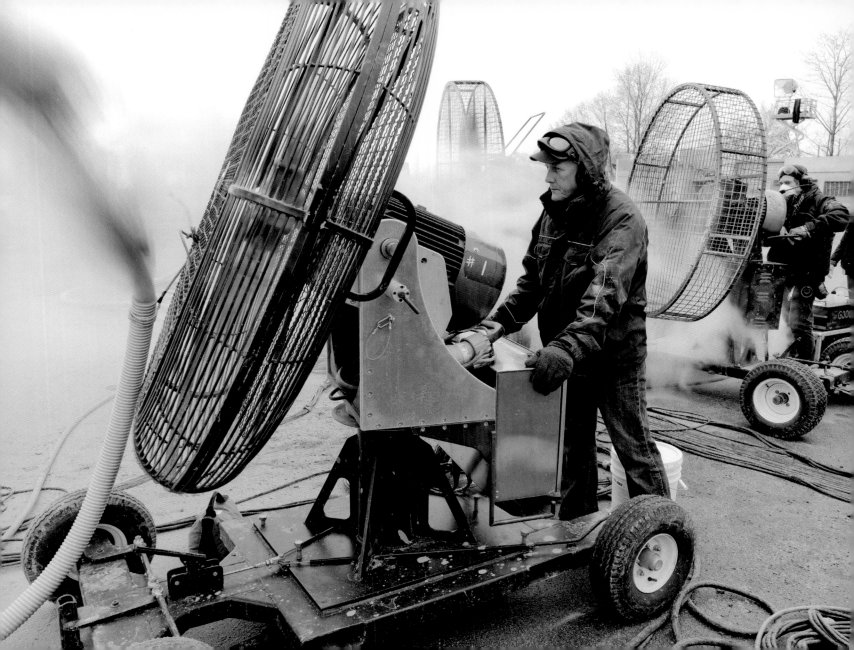

JAN 31 ' 11 [11:12:17]

Ethan uses a tracking device to find his route through the storm. The camera shoots the device over his shoulder and a well-protected assistant keeps it in focus.

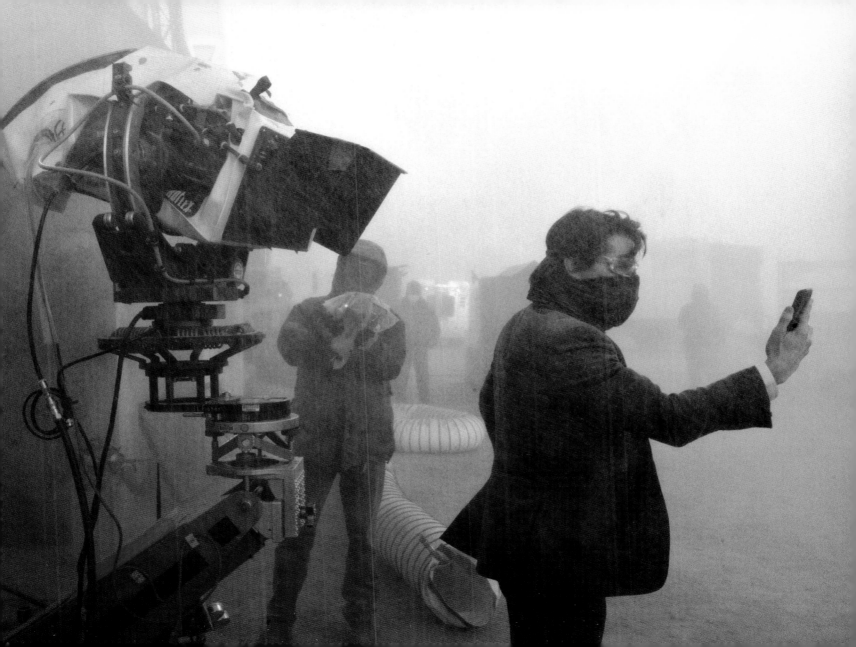

FEB 01 '11 12:10:57

The tracker's signal is faint in the middle of the dust storm, but still strong enough to point Ethan in the right direction.

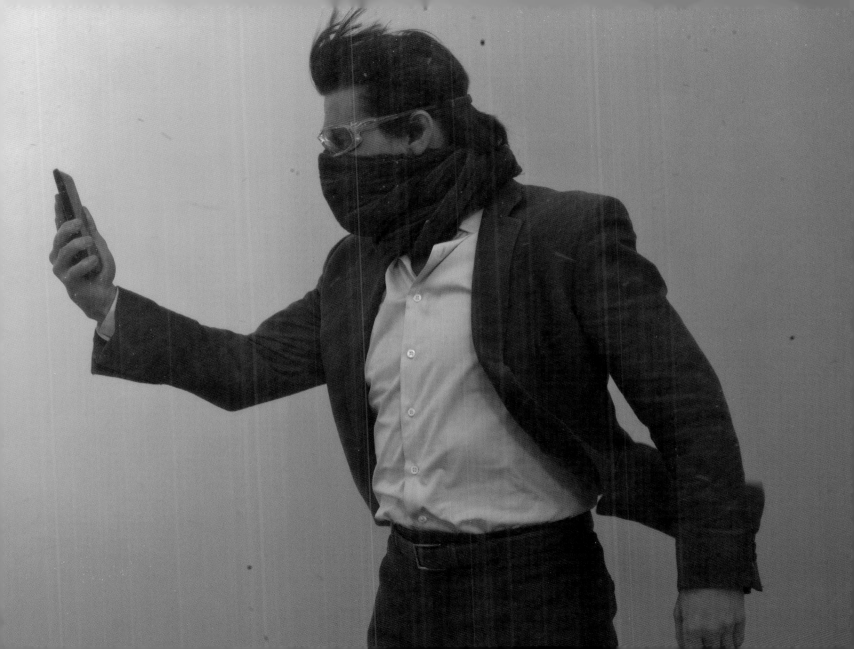

FEB 01 11 15:45:15

A rare sunny winter day in British Columbia. The wind machines re-create the dust storm, and the giant silks filter the sunlight. The very large black cover is used to keep most of the bright daylight off the set.

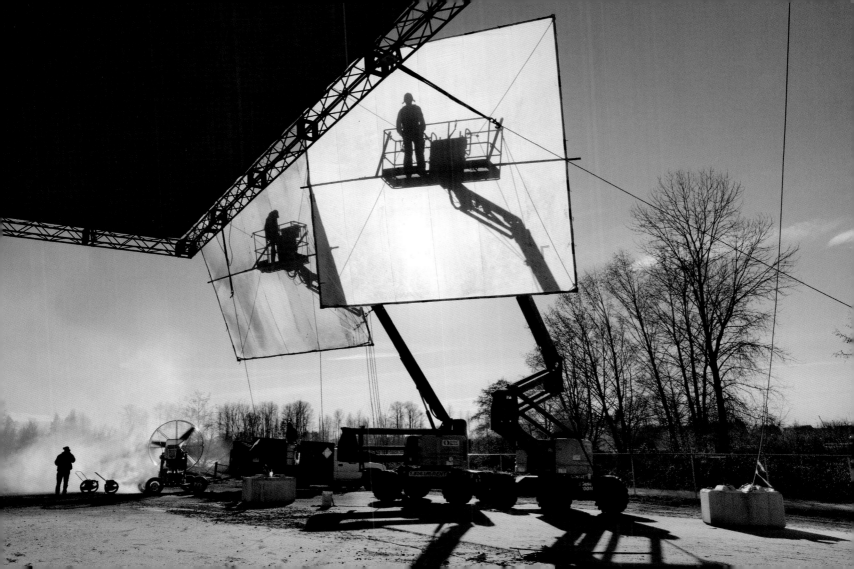

FEB 07 11 17:28:14

The revolving light above the BMW Vision EfficientDynamics makes it look like the car is passing under streetlights when filming in the interior.

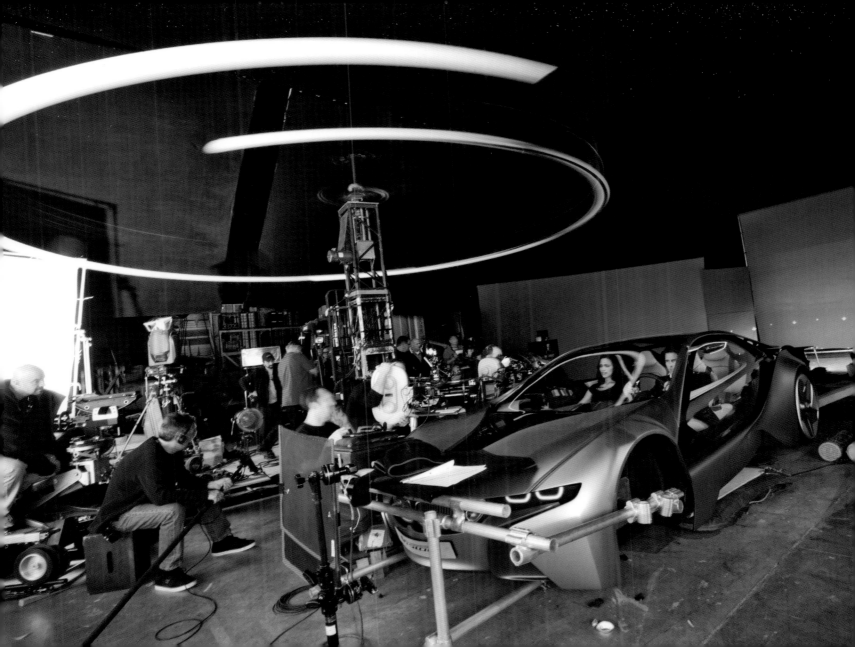

FEB 11 '11 15:10:25

We were shooting on a blue-screen set on a cold stage in studios outside Vancouver. In this shot, Tom is about to get inside an SUV for an important dialogue and action scene. Brad pulled him aside so they could discuss the scene in an area where he would have some room to express himself.

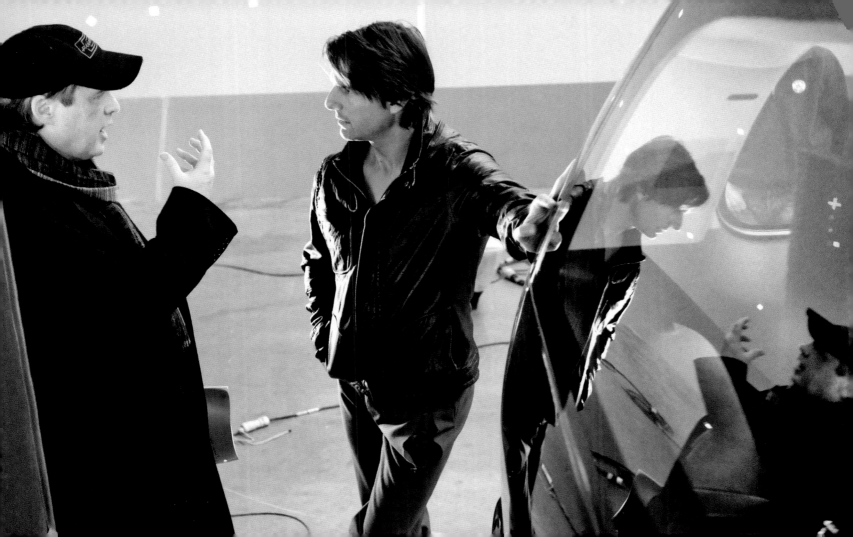

FEB 12 · 11 [15:50:29]

Special effects crew members make adjustments to the vehicle, which is about to be riddled with bullets.

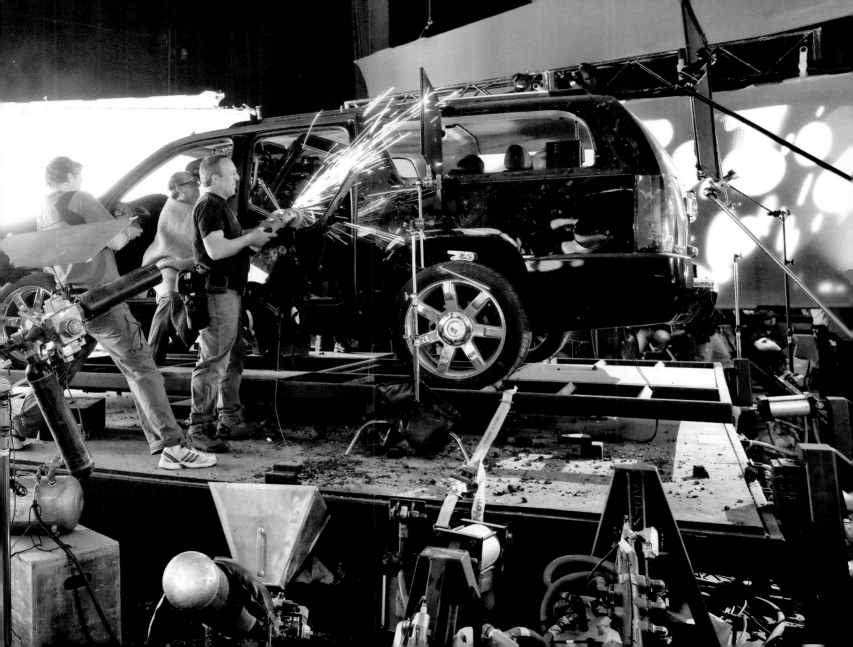

FEB 16 '11 13:33:50

Paula Patton, who plays Jane, is a rare beauty. I loved photographing her and could always rely on her to read the camera, which made it doubly fun to shoot with her.

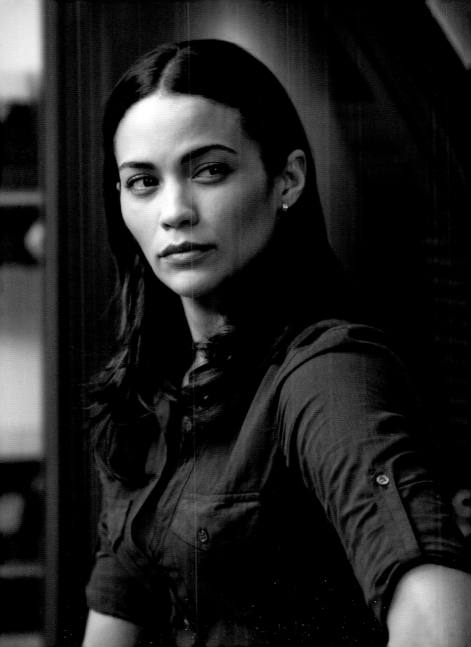

■ FEB 16 ˈ11 ⌐14:15:23⌐

A candid shot of Jeremy Renner on the IMF train set. I couldn't resist photographing him while he sat under those belts of ammunition. He has such a great face; every expression tells a story.

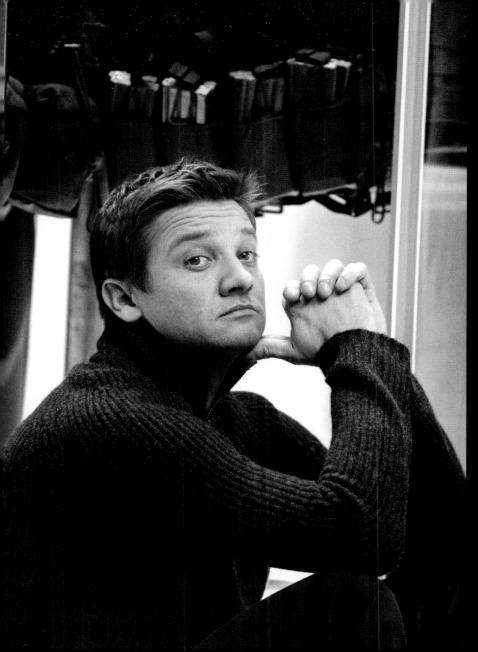

FEB 16 · 11 [16:38:26]

Benji (Simon Pegg) while in the midst of planning the Dubai mission. Simon was a fun person to photograph. We are both English, and I consider him very similar in personality to Sir Michael Caine, who I have had the pleasure of working with on more than one occasion. This became kind of a running joke on set, and Simon had fun teaching Tom to say, "Hello, my name is Michael Caine," in a very Michael Caine–like British accent.

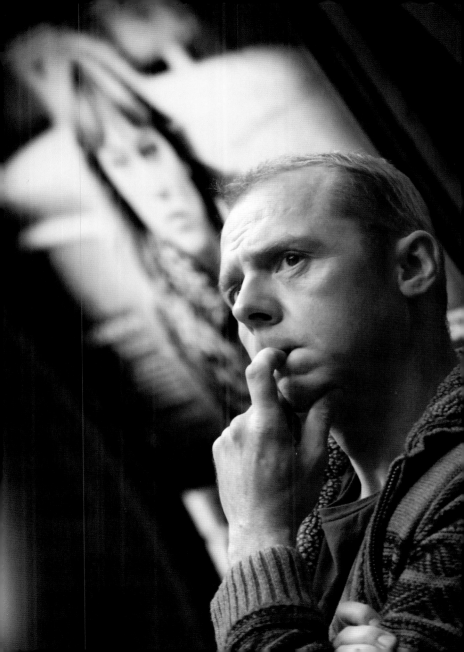

FEB 17 ' 11 [18:45:41]

The actors playing the IMF team after a hard day of shooting. This was a must-have picture, as we had just finished a long session.

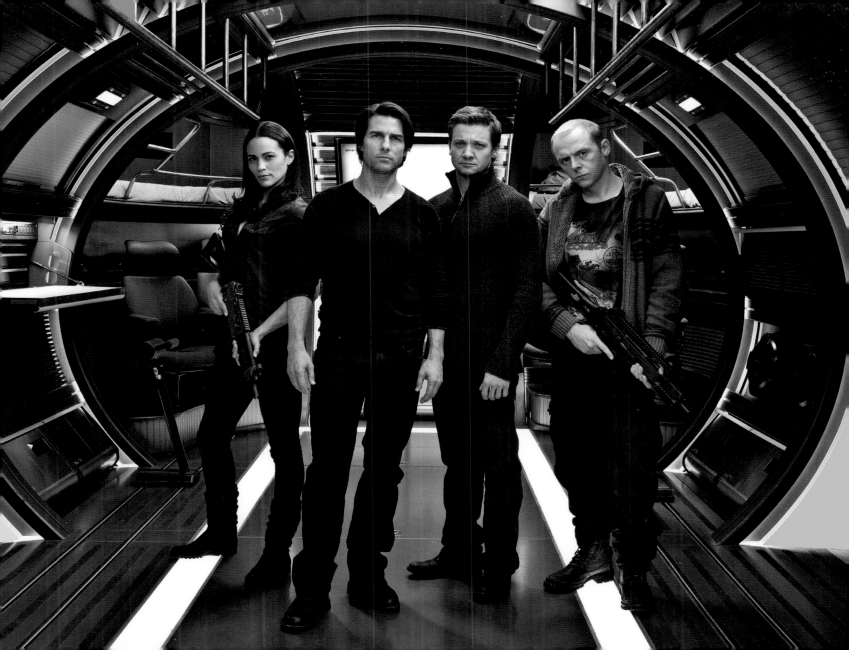

FEB 17 '11 20:02:25

Tom Cruise does a test run as a camera operator. He looked and acted like he knew exactly what he was doing behind the camera. I had asked him some time ago when and if he would ever direct a movie. His answer: "My first love is acting. I started to produce films because they weren't making the kind of movies I wanted to make. Directing is a 24/7 job. I have a family. My downtime away from the set is their time." Still, I would not be surprised if one day he takes the helm.

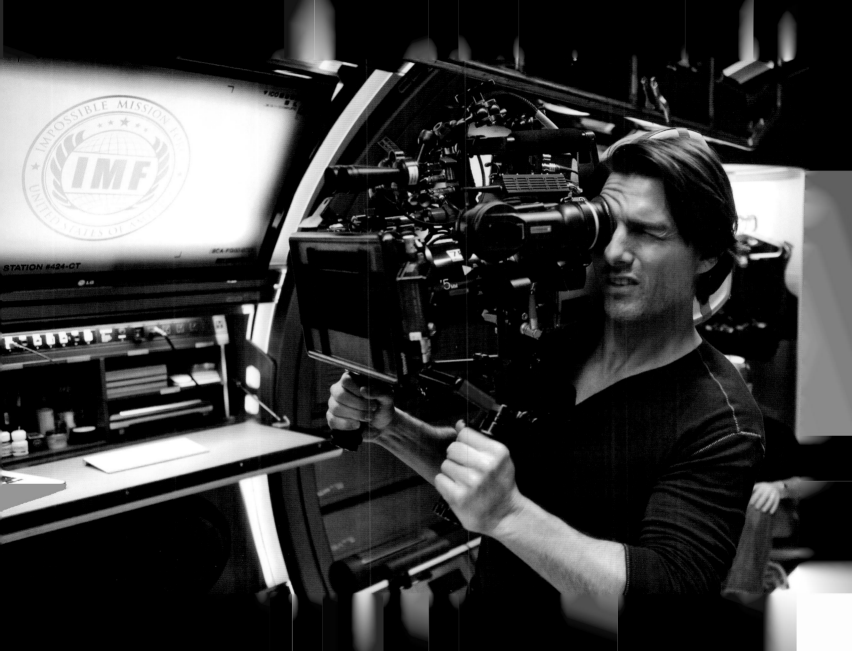

■ FEB 18 ' 11 [13:22:24]

This is a partial reshoot of the scene in the Dubai safe house where Brandt (Jeremy Renner) tells the rest of the team
(Jane, played by Paula Patton, and Benji, played by Simon Pegg) Ethan's backstory.

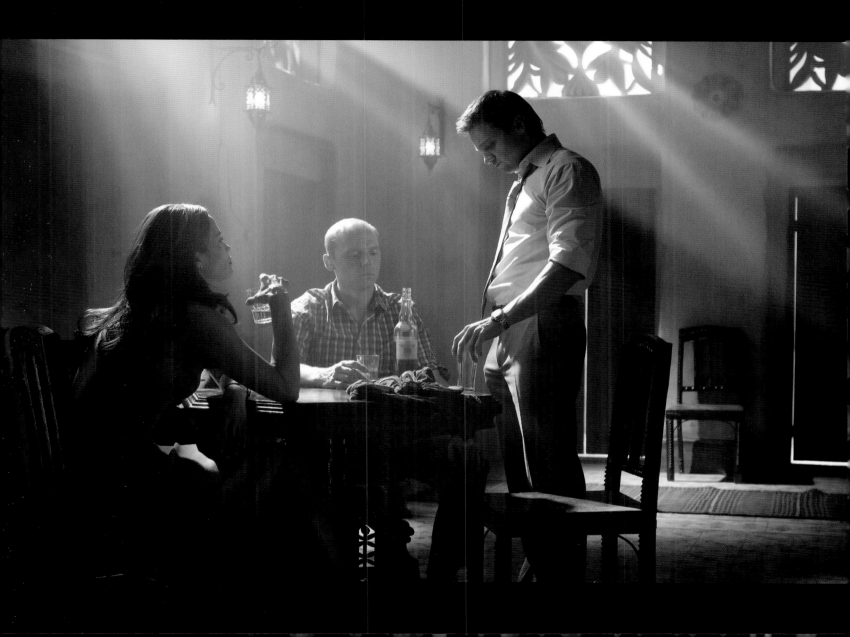

FEB 22 ' 11 10:39:08

This set is an interior at a radio station in Mumbai. Brandt (Jeremy Renner), trying to turn the power back on, fights Wistom (Samuli Edelmann). It was a very impressive fight; Jeremy did not need a stunt double. His past acting roles have trained him well for this line of work.

▪ FEB 23 ·11 ⌈ 17:14:16 ⌋

Ethan and Brandt (Jeremy Renner) escape the bullet-ridden Escalade when it sinks to the bottom of the river in Moscow. This was another first for me. I wasn't quite sure of my underwater skills, and I mentioned this to Tom. "So, this underwater scene . . . ," I said. "Hey, it's going to be great. See you down there," he responded. That was it; see you down there meant see you down there. The next day I had a diving rig, an underwater camera , and an experienced diver helping me make sure I didn't go up or down too fast. The special effects team made the water deliberately murky, setting up a "river flow."

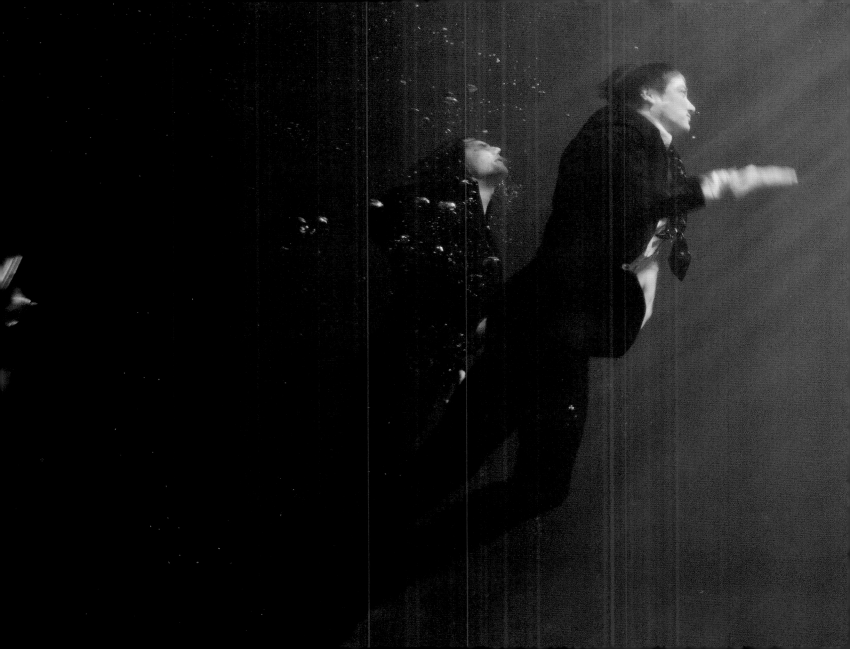

FEB 24 ' 11 12:50:12

Another day down in the deep, this time in a vast warehouse. Its main use was as a dry dock for repairing large ferries. It was February in Vancouver and extremely cold, even by British Columbian standards. Luckily, it was much warmer in a wet suit and in the water. Shooting underwater on a movie set is a blast. The subjects become ethereal, there are light shafts everywhere, and everything seems to happen in slow motion. I would do this again in a heartbeat.

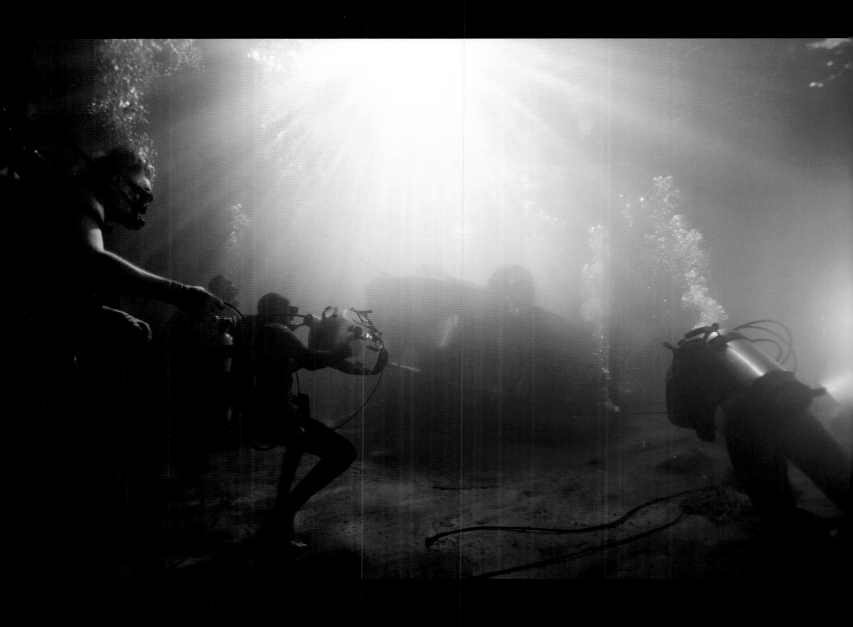

▪ FEB 28 ⸳ 11 ⸢ 13:39:19 ⸥

Ethan and Hendricks (Michael Nyqvist), our movie's true villain, fight in a parking garage in Mumbai. A massive multilevel garage, complete with a moving robotic arm, was constructed on set for this scene. It was a dangerous set, so we were all harnessed to lifelines, just like on the Burj Khalifa. The actors had to jump from level to level while the arm moved to park cars.

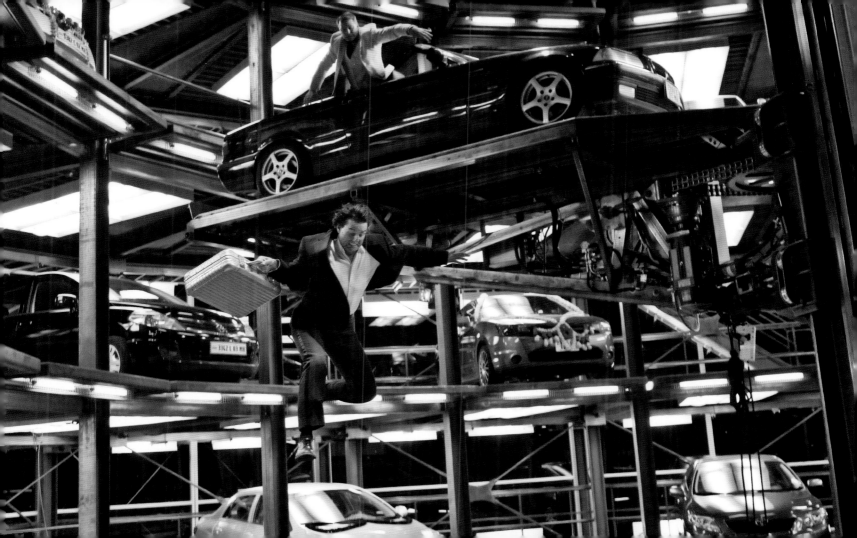

FEB 28 ı 11 [14:39:21]

Ethan and Hendricks continue the fight, both trying to get possession of the Cheget, which is a "nuclear briefcase" designed to be used by senior Soviet officials to communicate while making decisions about the deployment of nuclear weapons.

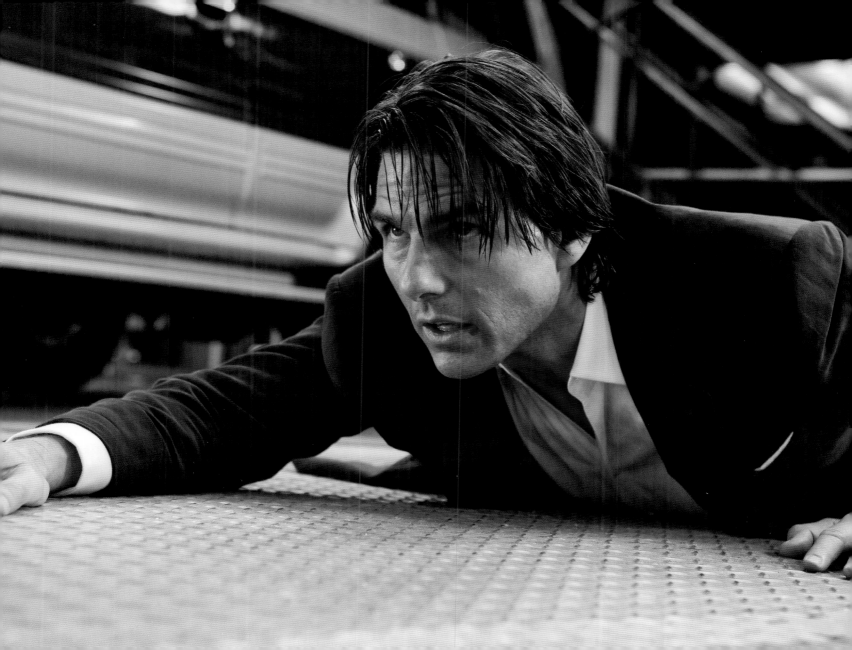

MAR 04 · 11 [07:41:01]

Hendricks (Michael Nyqvist) uses the Cheget as a weapon against Ethan. This was a difficult scene to photograph because the actors were all over the set, which was constantly moving around them.

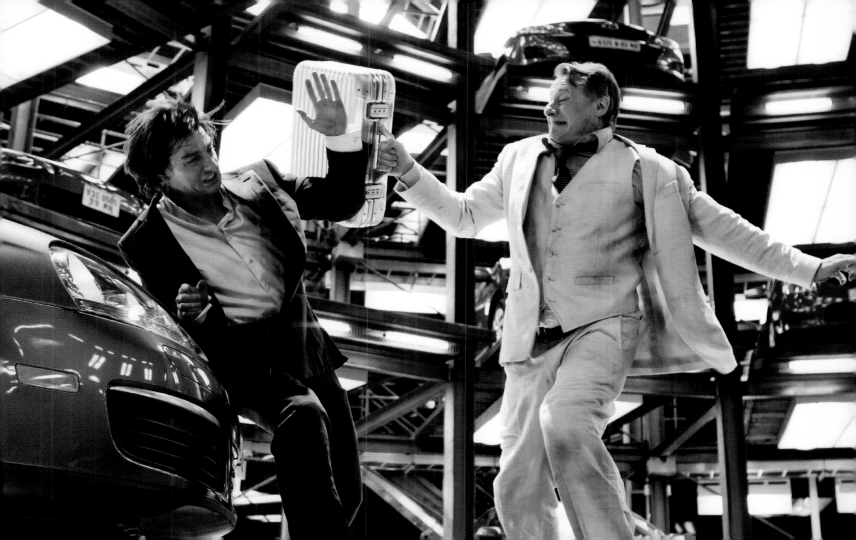

MAR 05 · 11 [11:09:05]

While we were shooting the parking-structure fight scene, Tom was hit in the neck with a piece of flying glass. The set had a lot of dark corners, so crew members had to hold up flashlights so the on-set medic could find the shard and remove it. Tom's only concern was to get on with the filming, telling the medic, "I don't have time to go to the hospital. Just glue me up and send me back in to finish the shot."

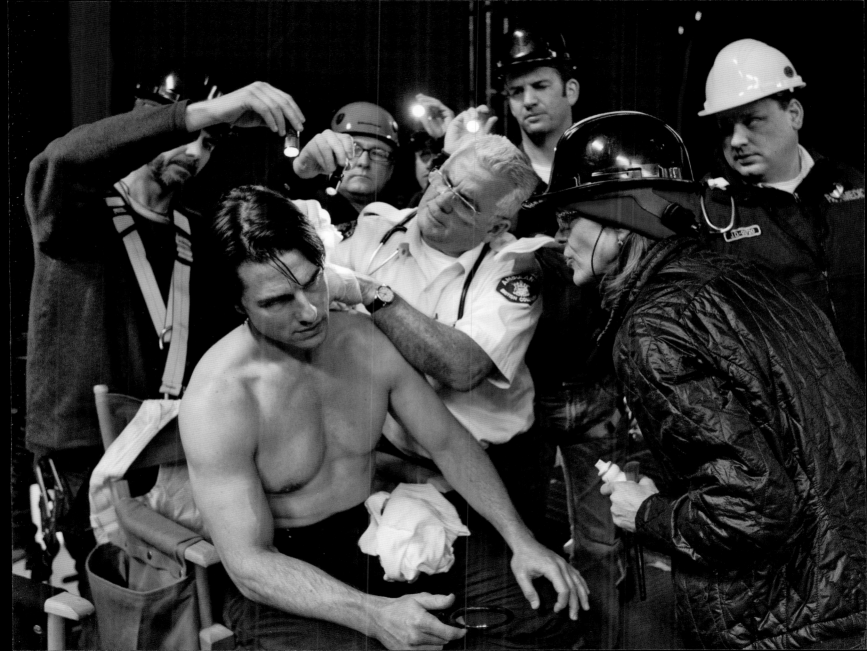

MAR 08 ' 11 ⌜14:33:11⌝

Tom takes a ride up in a lift to take a ride down in a car. This rig was used for a shot in which Ethan jumps into a BMW 1 Series and drives it over the edge to get to the bottom more quickly. The special effects team built the rig to make a controlled descent with the camera mounted inside the car. For the film, this footage will be sped up, hopefully making viewers gasp as the car plummets to the ground.

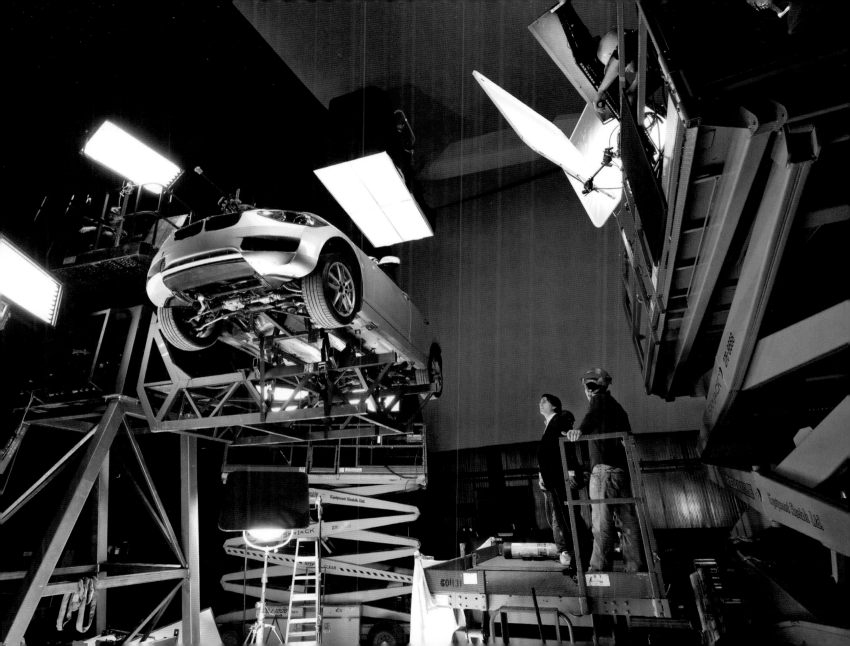

MAR 09 11 15:04:13

The car hits the ground and air bags break Ethan's fall. Despite the height of the fall, he crawls out and claws his way to the Cheget. Mission accomplished.

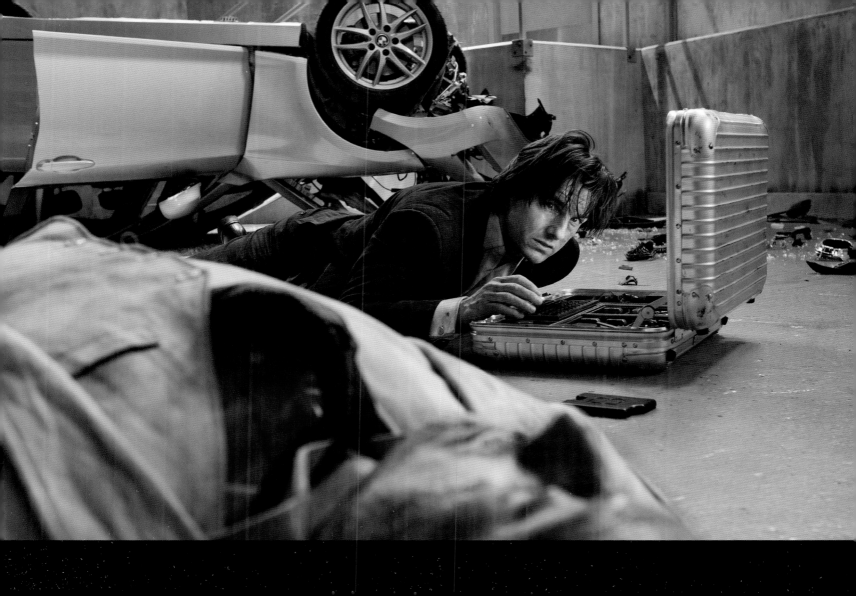

MAR 10 ' 11 [10:05:49]

Sidirov (Vladimir Mashkov) kneels beside Ethan and looks over at the case. He tells Ethan that his friend in Dubai betrayed him. "No," Ethan tells him, "he delivered my message." An intense scene follows, which nearly went bad during filming when the actor on the left wasn't watching and tripped over Michael Nyqvist.

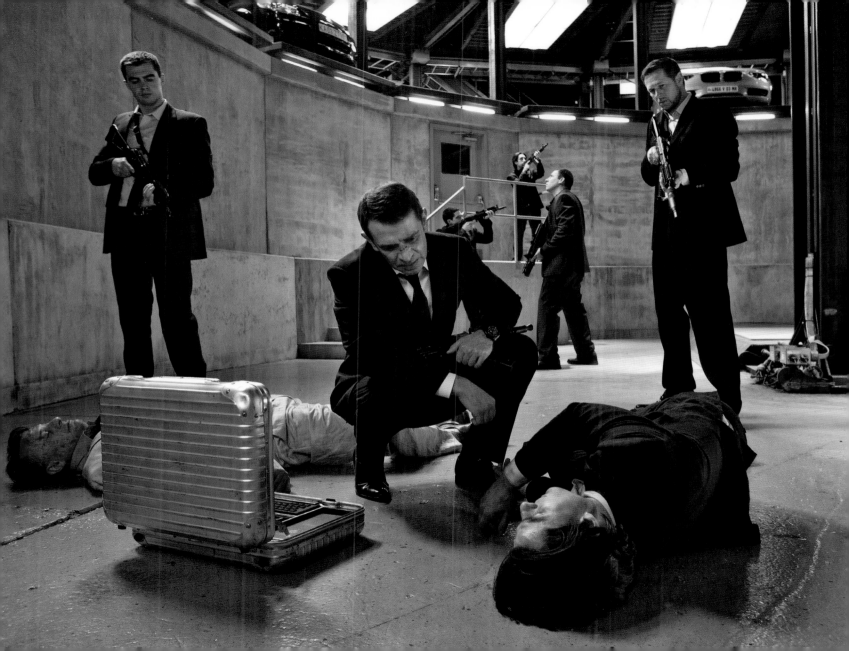

MAR 11 · 11 [12:32:35]

A camera crane was mounted on one robotic arm, with the actors and picture vehicle on another. Both arms had to move in concert with each other to get every shot right. Everything was controlled with computers, but it was a painstakingly slow process.

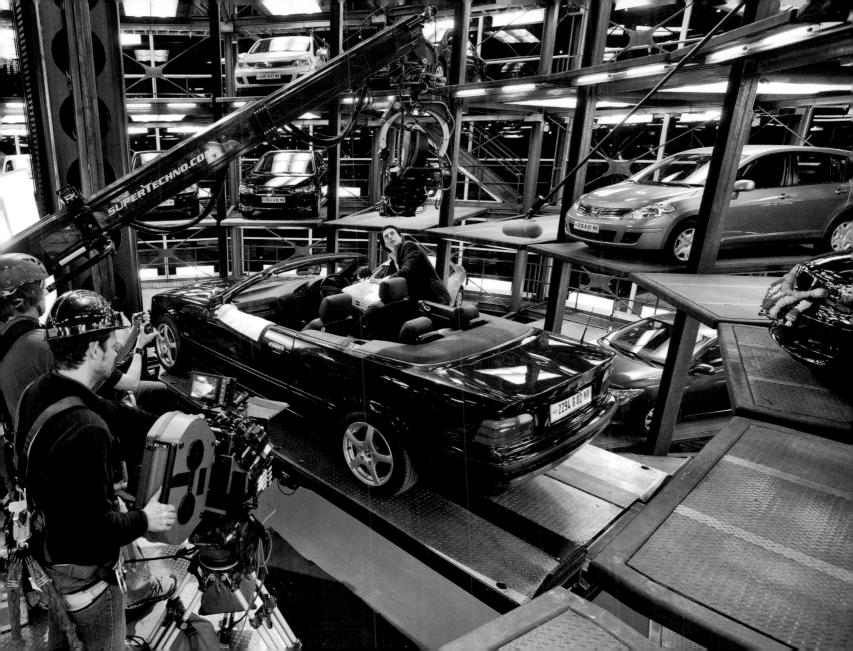

MAR 13 ˙ 11 [10:50:46]

Under the supervision of the stunt team, Michael Nyqvist practices a drop from an upper level. He was nervous about doing this stunt at first. But a successful take made him so elated, he wanted to do it again.

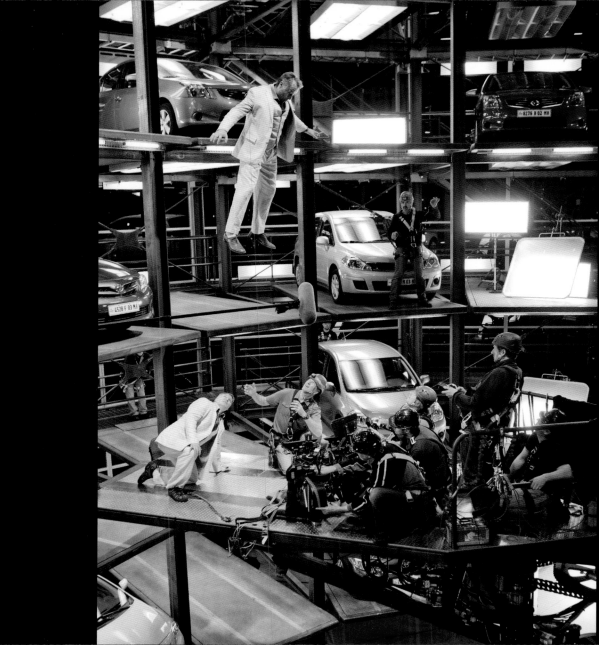

MAR 14 · 11 [11:42:48]

Ethan is handcuffed to a chair in the cargo hold of a ship. The two figures standing nearby are a mysterious arms dealer known only as The Fog (Ilia Volok, far right) and Bogdan (Miraj Grbic), Ethan's friend from prison. This set was extremely detailed and realistic. The art department did a fantastic job.

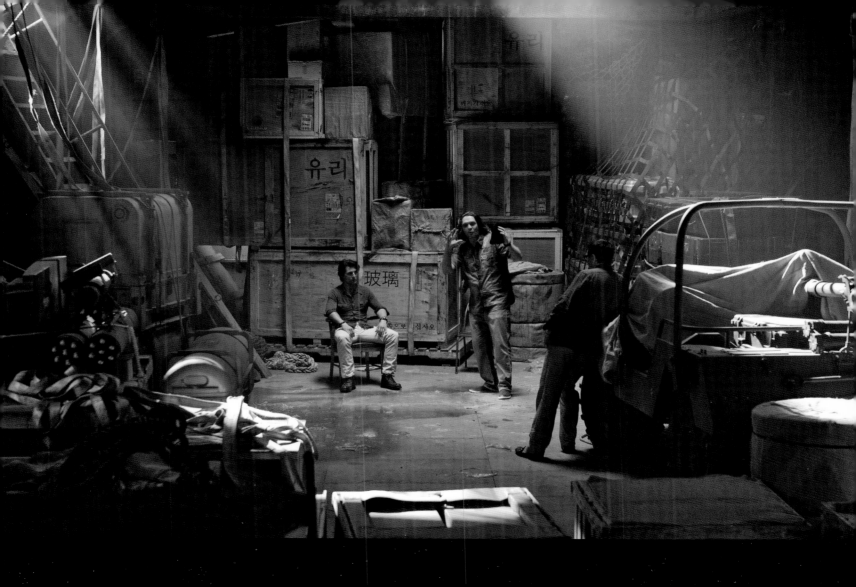

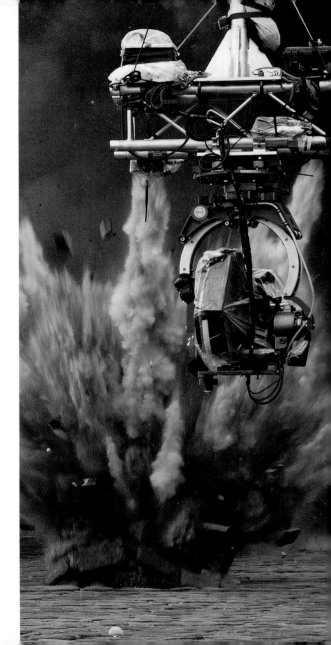

MAR 17 11 [08:40:47]

These days, visual effects have become so sophisticated that we often shoot pieces
of a final image separately and then put them all together in post-production.
In this shot, Ethan runs from the Kremlin as Hendricks's bomb goes off. In the
finished shot, you will not only see the bomb go off in the background, but you will
see the pavement lift and buckle behind Ethan, thanks to the visual effects team.
The camera is on a fling rig, as is Tom, who will be airborne at the end of the run.

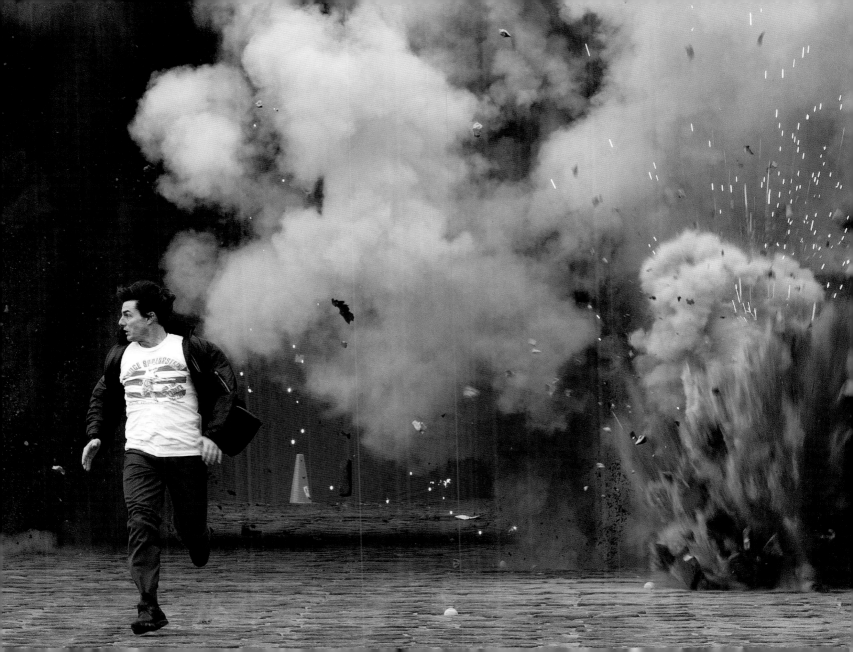

MAR 17 11 18:09:52

That's Tom hanging around in the sky, again. He loves it up there. The blue screens will make it easier for visual effects to place an appropriate background around him.

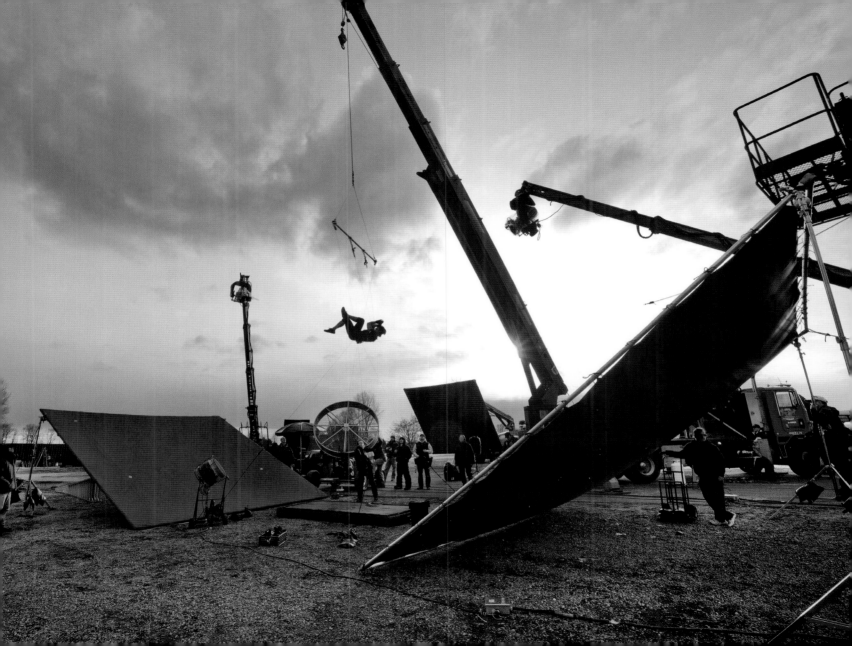

MAR 17 ' 11 [19:10:20]

It's over. On the last day of filming, first assistant director Tommy Gormley awards Tom a five-dollar bill for being the employee of the day. We are all elated; it's been an incredible journey. There are a lot of memories for us to take with us. It often happens in this business that you work with people on a movie and then meet them again years later, picking up the conversation where you left off. The filmmaking language is universal.

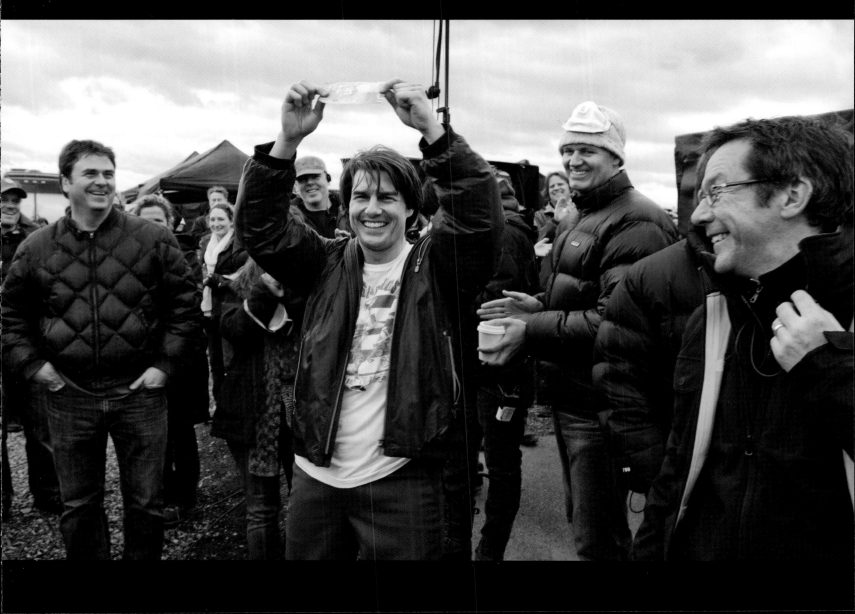

ABOUT THE PHOTOGRAPHER

DAVID JAMES WAS BORN IN BIRMINGHAM, ENGLAND, AND SPENT MOST OF HIS CHILDHOOD IN A VILLAGE IN HERTFORDSHIRE, JUST OUTSIDE OF LONDON. AT AGE NINE, HE RAN ACROSS A METRO-GOLDWYN-MAYER FILM CREW SHOOTING OUTSIDE THE VILLAGE SCHOOL AND KNEW FROM THAT MOMENT THAT HE WANTED TO BE A PHOTOGRAPHER IN THE FILM INDUSTRY.

James joined the stills department at MGM Studios in the United Kingdom at age sixteen, working in the lab as an assistant. David Boulton, the head portrait photographer, became James's mentor and arranged for him to work as a printer on the Otto Preminger–directed *Exodus* (1960), which led to photography work on many films to come. ■ David first worked with Tom Cruise in the UK when he was assigned to the special photography unit on Ridley Scott's *Legend* (1985). Since moving to the United States, David has worked with Cruise on six films, including *Mission: Impossible – Ghost Protocol*. ■ James's work has been featured in several international exhibitions, and he has received many awards and accolades, including the 2006 International Cinematographers Guild Publicists Award for Excellence in Unit Still Photography and the Society of Camera Operators' Lifetime Achievement Award. His photographs have been published in magazines and newspapers around the globe and are included in the archives of the Academy of Motion Pictures Arts and Sciences and the Professional Photographers of America organizations.